a beginner's guide to digital photography

Adrian Davies

contents

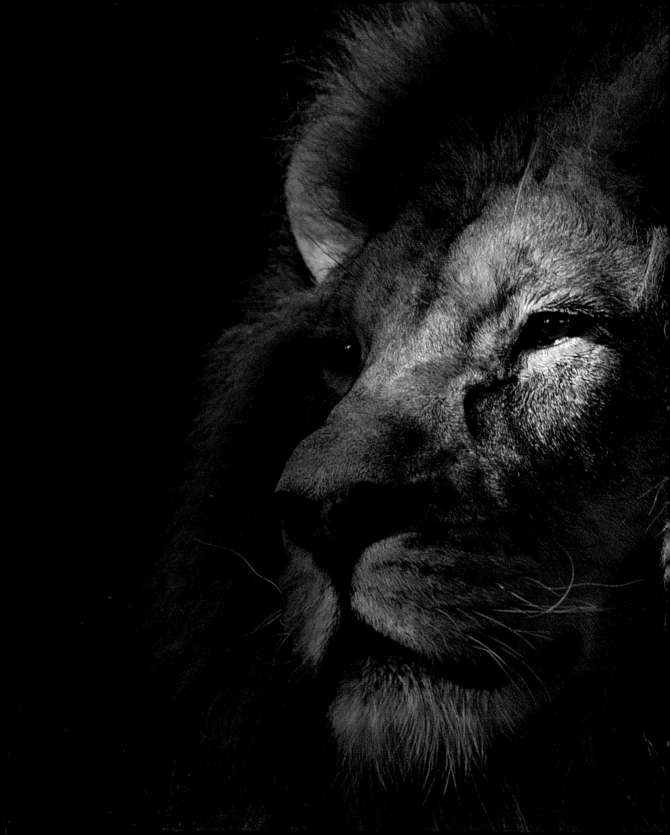

introduction

Photography comes from Greek words meaning painting with light and refers to the recording of light, reflected or transmitted by a subject on to light-sensitive material. Most photography up to now has used film together with a mixture of various chemicals, including silver salts mixed with gelatin, coated on to a flexible plastic base. This film requires processing in total darkness, in various chemicals, to produce the final images.

Today, this process, which has remained virtually unchanged for over 150 years is being rapidly replaced by an electronic, digital one, where images are recorded with light-sensitive silicon chips, and processed in computers. By mid-2001, digital cameras had begun to outsell film cameras!

However, the fundamental principles of photography, an appreciation of light and composition, and the ability to tell a story with an image, are just as important as they ever were.

This image of a lion by Bryan Powell was taken late in the day in winter sunshine at a zoo, with light still coming through the trees. Very little image enhancement was required, other than darkening the background in one or two places to provide a suitable backdrop, and add more contrast to make the lion stand out more dramatically.

the digital cycle

shoot

enhance

share

A picture can be taken, downloaded on to your computer and emailed to the other side of the world in a matter of minutes all at an affordable price.

Understanding the digital imaging process is as simple as understanding the principles shoot, enhance and share.

Whether you shoot your image digitally or take it conventionally, you can scan or load it on to your computer with little difficulty. Digital imaging techniques are at your fingertips. Enhancing, retouching or manipulating your image can be done in a few easy steps.

But more than just producing a final print you can save and store your images, or share them with friends, relatives, and clients with the mere click of a mouse.

Digital pictures can be obtained either by using a digital camera, or by digitising existing conventional negatives, transparencies or prints.

Whether you shoot digitally, or on film, the basic techniques and skills of creating a good image remain the same – content, composition, and appreciation of light are all paramount to the success of a good image. It is possible that for many of your images, the amount of processing in a computer will be minimal – perhaps just subtle changes to brightness and contrast, whilst other images may require extensive retouching or manipulation.

Once in digital form, the images can be loaded into a computer, where image-processing software can perform a large number of functions, such as changing the brightness, contrast or colour of the images. This allows you to retouch them, or manipulate the content, by swapping elements around for example.

The images need to be stored, perhaps on CD, and in such a way that they can be easily retrieved in the future. Finally, you will want to output your images, probably as prints, but also perhaps as part of a web page, or multimedia production.

shoot

analogue:
photograph
transparency

digital:
scanner
digital camera
digital video

enhance

save data to computer

computer

manipulate
retouch

share

share data

save
archive
send

print
film
internet
email

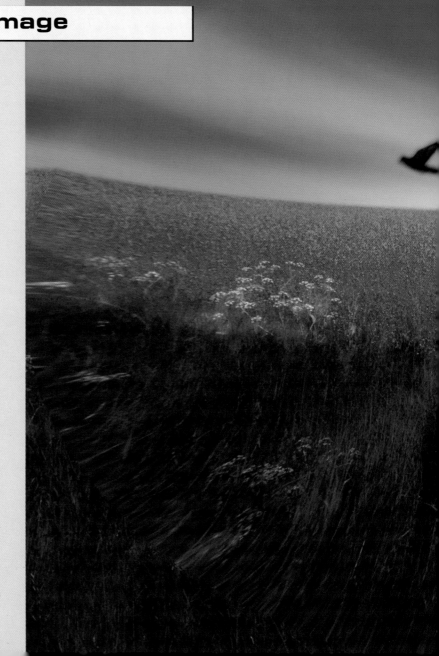

capturing the image

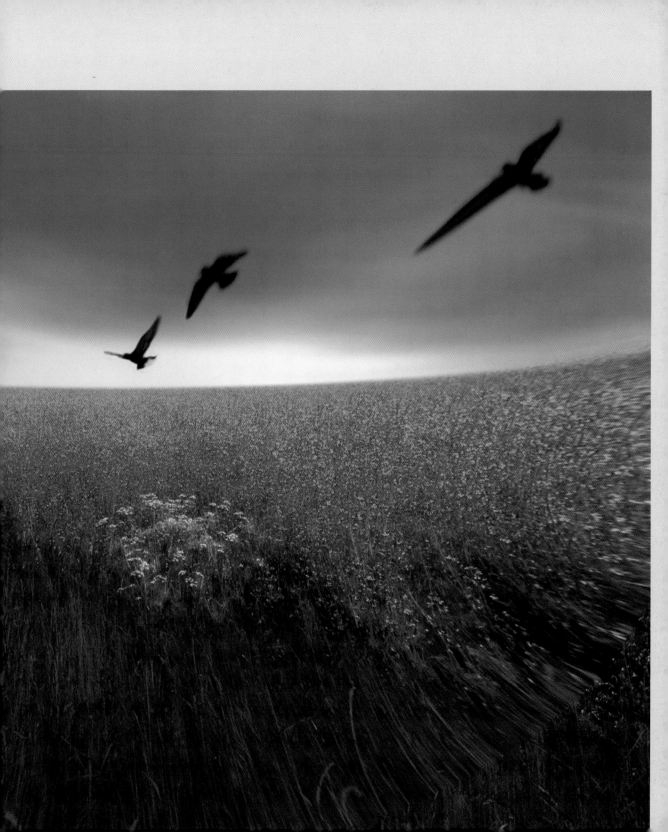

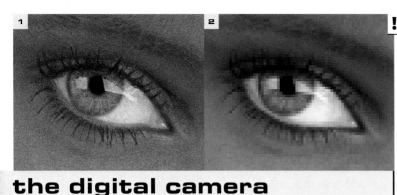

1

2

! <u>Grain versus pixels</u> –
Photographic film is composed
of countless millions of
irregularly shaped grains of
silver, which make up the
photographic image. In digital
systems, the image is composed
of square pixels. The more pixels
an image is made up of, the
higher the resolution and better
the quality.

the digital camera

A digital camera is
basically the same as a
film camera: it has a lens,
aperture and shutter, but
replaces the film with a
light-sensitive silicon chip
called a **CCD (Charge
Coupled Device)**. This
device consists of a
mosaic of square picture
elements, or pixels, each
of which is sensitive to
light and acts like a light
meter. The more light
falling on a pixel, the
greater the electric
current generated.
Colour is recorded by
coating each pixel with a
transparent red, green or
blue filter. Software in
the camera integrates
the colour from a group
of four pixels to create
the illusion of full-colour
images.

resolution

In general, the more pixels a
camera has, the better the
quality, although there will be
applications such as web use or
multimedia where high quality is
not always necessary. Cameras
with 3 million pixels or more are
common and can yield excellent
results at printing sizes of up
to A3.

The way in which you store the
images will affect their quality.
Many cameras offer different
quality settings – <u>fine</u>, <u>better</u>, or
<u>best</u>, for example – so always use
the highest quality you can for the
best results.

camera types

There are now many different
<u>digital cameras</u> on the market, at
a range of prices. With <u>single lens
reflex cameras</u> you can change
the lens and the subject is viewed
through the <u>same lens that takes
the image</u>. SLRs are still
expensive though, so most digital
models at present are of the
<u>compact</u> type. In this design the
<u>viewfinder lens is separate from
the lens taking the image</u>, rather
like the view given by our right and
left eyes. The only drawback with
this is that it can lead to problems
with *parallax*, particularly with
close-ups, when the top or bottom
of a subject is cut off.

LCD display

The LCD (liquid crystal display)
viewing screen on the back of
most digital cameras is very
useful, and one of the main
advantages of digital over film
cameras, but it can be difficult to
see in bright daylight. Several
manufacturers make viewing
hoods that stick on to the outside
of the camera, but you can easily
construct one yourself from black
card and Velcro.

3 analogue subject

4 digital subject

1/ An exaggerated view of the film grain in a conventional photograph.

2/ In digital imaging the grain is replaced by square pixels, each of which has a specific brightness and colour.

3/ Analogue signals are continuous, and cannot be loaded into a computer.

4/ Digital signals are discrete values – the analogue signal is <u>sampled</u> by the CCD sensor.

5/ Digital cameras are basically the same as film cameras – a lens and shutter, focusing the light on to a light-sensitive surface, in this case a CCD sensor.

6/ The <u>CCD sensor</u> contains <u>light-sensitive pixels</u>, each of which is coated with a transparent coloured filter, <u>red</u>, <u>green</u> or <u>blue</u>.

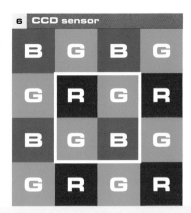

6 **CCD sensor**

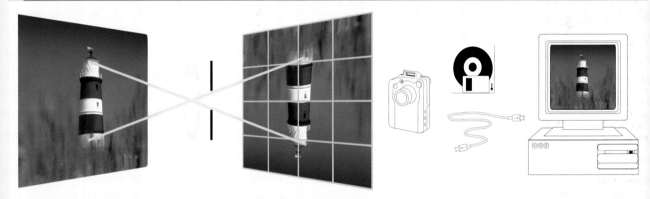

5 >>>>>>> subject >>>>>>>> lens > shutter >>> CCD sensor >>> digital data >>> camera >>> disc >>>>>>>>>> computer >>>>>

>>>>>>>>>> subject >>>>>>> lens > shutter >>> CCD sensor >>> digital data >>> camera > direct connection >> computer >>

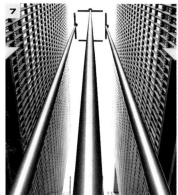

7/ A wide-angle view of skyscrapers and flagpoles by Phil Preston. Different lenses can give very different images of everyday subjects!

8/ The same image distorted further by image processing and toned blue.

lenses

Cameras with interchangeable lenses allow you to easily switch from wide angle to telephoto, but screw-in attachments are available for many compact types, which means they can shoot in either wide-angle or telephoto mode.

The focal length of a lens relates to the angle of view. Due to the small size of the CCD sensor, lenses for digital cameras are much shorter than their 35mm film camera equivalents. A zoom lens of perhaps 8–24 relates to approximately 38–115mm. Many compact types of digital camera have a standard focal length lens of around 38mm. This has an angle of view approximately the same as the human eye. Wide-angle lenses are shorter, perhaps 15–20mm, whilst telephoto lenses are longer. Most digital cameras have zoom lenses, ranging from perhaps 35–100mm.

Several manufacturers make extra lenses that screw into the camera lens, to extend the telephoto or wide-angle range. Even though most digital cameras have zoom lenses, there may be occasions when you need a wider, or longer lens. Various attachments can be purchased which screw into the front of the lens to increase its capabilities.

camera controls

Being able to adjust the shutter speed or aperture is important if you are going to control your images, so choose a camera that allows you to override the auto exposure settings. Some cameras allow shutter or aperture priority, allowing you to give priority to either depth-of-field or subject movement.

Other in-camera effects allow you to make adjustments for the type of lighting present – daylight, tungsten, fluorescent etc. This will help ensure the correct colour. Other built-in effects, varying from model to model, are the ability to shoot in monochrome or sepia, though it is often better to do this sort of thing later in the image-processing software.

flash

Flash has many uses, from lighting the whole subject to just adding a sparkle to an otherwise dull image. Most compact types of digital camera have built-in flashes, but beware; these are situated close to the lens and can result in hard shadows behind the subject, or effects such as 'red eye'. If possible use a flash external to the camera, to allow you to position it carefully.

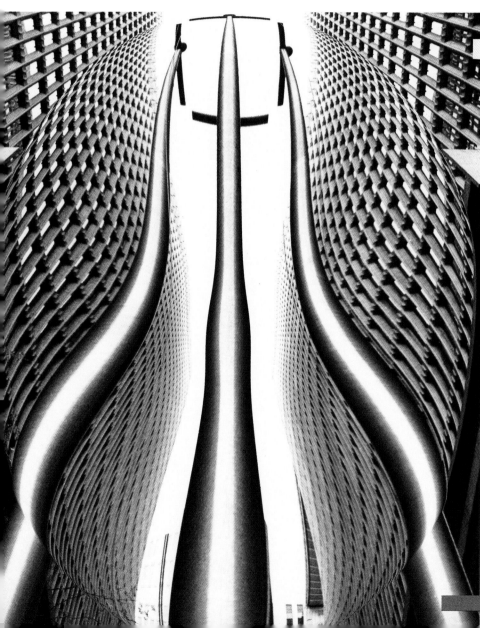

Tripods are often thought of as being heavy, cumbersome and awkward to carry. But tripods do two things. First, they hold the camera steady, leaving you to worry only about any movement of the subject. Secondly, they slow you down and almost force you to consider carefully the light and composition, and look around the edges of the frame for any distracting elements such as unwanted branches or lampposts etc. I find a particularly useful accessory to have when using a tripod is a small spirit level, which can be placed on top of the camera to make sure horizons are straight in landscape images [9]!

shooting close-ups

shoot

enhance

share

Most compact digital cameras allow you to photograph small subjects in <u>macro mode</u>. This is particularly useful for inanimate objects such as coins, stamps or flowers, for example. Check how close your camera can go to the subject and still focus, although you can buy supplementary lenses that screw on to the front of the camera lens to enable it to focus more closely. Single lens reflex types of camera are better than 'direct vision' types as they enable you to frame accurately without the danger of parallax.

I <u>shot</u> this flower close up as part of a series for an exhibition called *Digital Flowers*. The aim was to show how good <u>digital cameras</u> now are for producing images like this. The plant (a South African *Protea*) was growing in a botanic garden greenhouse, and was several feet away.

The first shot was disappointing [1], so I set the lens to its <u>telephoto setting</u> and moved the camera position so that I could fill the frame with the flower. It was essential to use a <u>tripod</u> as the light level was low, so a <u>long shutter speed</u> (1/4 second) was needed. I decided not to use flash, as I didn't want harsh shadows.

I felt that the second image was much stronger.

The image required relatively little in the way of enhancement, showing that it is worth taking the time and trouble to get it right at the taking stage [2]. I adjusted the density range of the image using Photoshop's <u>levels controls</u>. I also <u>cropped</u> the image to a square format, which suited the flower better than a rectangle.

The aim was to produce a <u>print on A3 paper</u>, at approximately <u>12in</u> (30cm). I knew from previous images that this would require a <u>file size</u> of around <u>24–25Mb</u> if I was printing at a resolution of <u>200 ppi</u> on my <u>ink jet printer</u>.

As the image from the camera was only 7.4Mb, I needed to <u>increase its size</u>. I did this by <u>re-sampling</u> using the <u>image size dialog box</u> [3]. I checked the re-sample image box and inserted the new dimensions into the box. As you can see, the <u>file size</u> was increased from <u>7.4Mb</u> to <u>24.5Mb</u>.

I applied an <u>unsharp mask</u> before printing the image on to <u>photo quality glossy paper</u> to retain all of the fine detail.

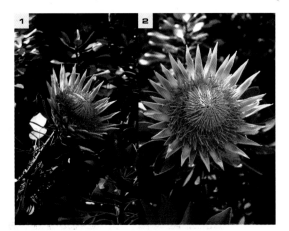

3 image size

Pixel Dimensions: 24.5M (was 7.4M)

Width:	2849	pixels
Height:	3000	pixels

OK
Cancel
Auto...

Document Size:

Width:	14.245	inches
Height:	15	inches
Resolution:	200	pixels/inch

☑ Constrain Proportions
☑ Resample Image: Bicubic

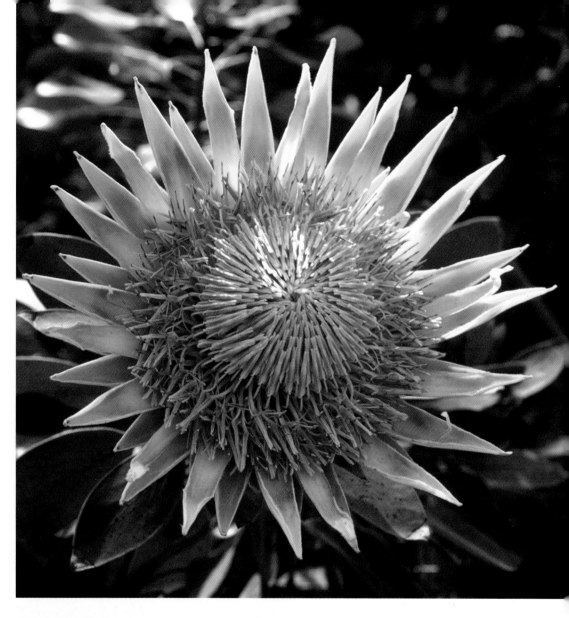

1/ The first shot of the flower was disappointing.

2/ Moving closer produced a much more striking image.

3/ Image re-sampling or re-sizing in Photoshop using the image size dialogue box (note the increase in image size from 7.4Mb to 24.5Mb).

CCD sensor and light on movable track moves down image at **1200** stops per inch.

600 dots collected for every inch of original.

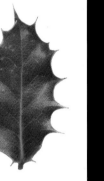

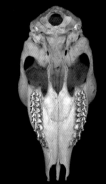

using a scanner

first steps

There are two basic types of scanner, the flatbed, designed for reflective print material, and the film scanner, for negatives and transparencies. Many flatbed scanners have transparency adapters to enable them to scan both.

Flatbed scanners have a linear **CCD** consisting of three rows of pixels, one for each of the three primary colours: red, green and blue. Attached to this is a strip light which shines light on to the surface of the print. As the **CCD** and light are moved across the surface of the item to be scanned, light is reflected and measured by the pixels, and converted into digital data for the computer [1].

Most scanners are operated through a TWAIN interface [3].

The basic procedure is to perform a pre-scan, or preview, which produces a low resolution version of the entire scan area. This can be cropped so that you only scan the required section of the image. Make sure you select the right type of material to be scanned – black-and-white print, colour print, line image, or transparency if you have a transparency hood fitted.

Next, select the resolution required. This will depend on what you are going to do with the image – make an A4 or A3 print, or use in a website for example. Many scanner programs allow you to set this automatically, according to the printer you are going to use. When buying a scanner, choose a model that has a resolution of at least 600 ppi optical resolution.

film scanners

If you intend to scan 35mm negatives or transparencies it is worth considering a dedicated film scanner. These will usually take either single mounted slides, or strips of negatives. You will need a scanner that can scan to a resolution of at least 2000 ppi in order to produce A3 sized prints. Their operation is very similar to flatbed scanners, as shown here [4].

scanning 3D objects

It is possible to use flatbed scanners to digitise images of three-dimensional objects. Due to the depth of the object, interesting results can be obtained [2]. Try translucent subjects too, such as flowers.

! If you have a monochrome image do not scan it in colour – it will be three times the size it needs to be!

! Don't scan more than you need to – it will only use up disc space and memory!

! Treat the glass surface of the scanner with great care. Any dust or scratches will appear on the final image, and will need to be retouched afterwards.

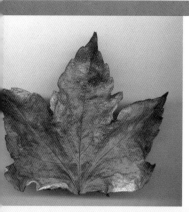
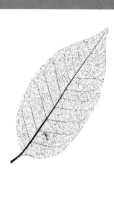

3 flatbed scanner interface

EPSON TWAIN — EPSON

Document Source:	Flatbed
Image Type:	Color Photo
Destination	EPSON Stylus Printer(Photo)
☐ Unsharp Mask	
Source:	W 5.00 H 6.00 inches
Target:	W 8.30 H 9.96 inches
Resolution:	200 dpi 9.46 MB
Scale:	13 4800
	166 %

Preview

Settings...
Configuration...
Full Auto Mode...
Scan
Close
Help

4 film scanner interface

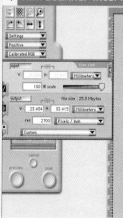
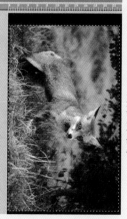

Settings
Positive
Calibrated RGB

input
W H Millimeters
100 % scale

output
file size : 25.3 Mbytes
W 23.434 H 33.415 Millimeters
res 2700 Pixels / Inch
Custom

preview scan cancel

1/ An example of a typical flatbed scanner.

2/ 3D objects scanned on a flatbed scanner:

Holly leaf – I have replaced the resulting grey background with white. The scanner lid was left open so as not to flatten the leaf.

Skull of roe deer.

Autumn leaf.

Leaf skeleton – the scanner lid was closed to flatten the leaf and ensure sharpness across the whole surface.

Antique photographic exposure meter – scanning is an excellent way of recording objects like this.

Fossil ammonite.

3/ TWAIN interface for the flatbed scanner. The dialog box shows that scanning a 6 x 5in print to produce a 10 x 8in print (approximately) on a photo quality ink jet printer requires a scan resolution of 200 dpi giving a file size of 9.46Mb. Notice the cropped area to be scanned and that the unsharp mask sharpening facility is not selected. It is usually best to sharpen images after scanning with image-processing software.

4/ Interface for a typical 35mm film scanner. In this case the transparency is being scanned at a resolution of 2700 ppi giving a file size of just over 25Mb, more than enough for a high quality A3 print.

! Scanning resolution – The resolution at which you scan an original is primarily dependent on what you are going to do with the image – whether you are going to print it, use it in a web page or send it as an email attachment, for example.

For printing, scanner software usually has an area to input the size of the original, the size of output required, and the printer resolution. In example [3], a 6x5in original is to be scanned to produce a 10x8in print on an ink jet printer at a resolution of 200 dpi. The scanner software automatically tells you that the file size will be 9.46Mb.

Whilst most scanner software will let you change the brightness, contrast and sharpen images, leave all of this until you import the image into your imaging software. You will have much more control.

Now press the scan button!

! The following images
illustrate many of the
features and advantages that
digital imaging now has over
conventional photography.

the digital image

2

composition

Just as in the darkroom, images can be <u>cropped</u> to enhance the composition. Elements, such as a bird, tree or even a moon can be <u>added</u> to balance the picture, or create a more dynamic effect.

Ever since its invention, photographers have been able to enhance, modify and even manipulate photographs. This could be either in the camera, by double exposing the film, or in the darkroom, where two or more negatives could be printed on to the same sheet of paper. Areas of prints could be lightened or darkened using dodging and burning. Exactly the same techniques can be used with digital imaging, but to an extent undreamed of by photographers before.

lighting

Photography is all about light, and the success of any image depends on how well you capture the quality of the light falling on a subject. And light isn't always perfect, unless you <u>control</u> it in a studio setting. Digital imaging allows you to <u>modify</u> the contrast of the light, as well as introduce special effects such as lens flare.

colour

Colour too can be <u>enhanced</u> or <u>modified</u>. Subtle washed-out colours can be <u>saturated</u>. Saturated colours can be <u>de-saturated</u>. But more than that, individual colours, or a range of colours can be altered, allowing you to turn fresh green leaves into autumn colours if you wish.

1/ Lake Tekapo – the original image shot in terrible weather.

2/ The final image of Lake Tekapo, with added sun to balance the composition.

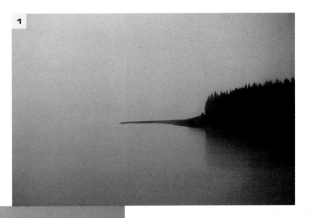

1

This image from Lake Tekapo, New Zealand by Jon Bower, dates from the early 1980s. 'Like all my images, it started life as a low-grain (slow film speed) 35mm transparency. The image was actually shot in driving, torrential rain. I still remember the water flooding off my hood, rucksack and camera bag. The rain was so heavy that the sky and ground seemed to melt together. However, this finger of land and trees, jutting into the lake, still stood out from the murk. Strong form always attracts me photographically, so I warily grabbed a few shots without drowning my camera and then trudged on.

'I returned to the image recently, and started off by completely de-spotting and removing flaws with the cloning tool, viewing the image at pixel level. You cannot get away with any spots or blemishes in commercial images, and 20-year old slides, however well kept, nearly always need a bit of attention, if only for dust.'

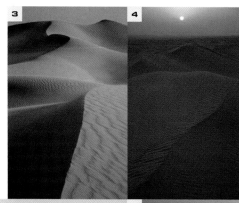

3/ The original image of sand dunes with a bland sky.

4/ Sand dunes later in the day, with the setting sun.

5/ The final image with the dunes and sky merged together.

6/ The original image of the trees.

7/ The original image has been distorted to elongate the shape of the trees. The colour saturation has been increased and a filter applied to impart a glow to the final image.

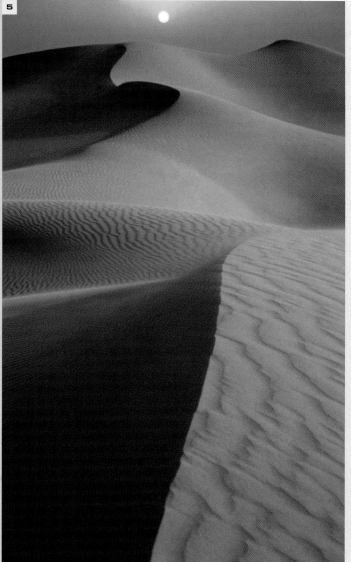

This sand dune shot is also by Jon Bower, and he has used the same techniques of montage and colour adjustment to enhance the image in the same way as the Lake Tekapo image on the previous page. This time the lighting was harsher.

'I really liked the light on the dunes, but felt that the sky was very bland and boring. I took another shot later in the day, of the dunes with the setting sun and set the exposure so that I exposed the sky correctly, not the dunes. I later merged the original dunes and the new sky together, to produce an image which I felt was far more satisfying.'

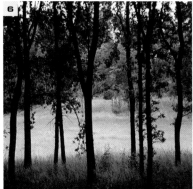

6

7

Photographers have always been able to change the composition of their images by choosing whether or not to crop the negatives in the darkroom. Digital images can be cropped and also distorted. This image, *Trees* by Phil Preston, has been distorted to elongate the trees. This seems to focus the eye on the trees. Phil has finished the image by enhancing the saturation of the colours, and using a filter to apply a glow to the image, giving a very ethereal feel to it.

image processing

software programs

There are many software programs available for enhancing, retouching and manipulating digital images, ranging in price from several hundred pounds to at least a couple that are freely available on the internet.

Despite the range of prices, all imaging software will have certain features in common, though these may be referred to differently in each program.

There are many software programs available for enhancing, retouching and manipulating images. The screen layouts will look different and the menus may have different titles but all imaging software will have certain features in common.

All will have the facility for altering the brightness, contrast and colour balance of an image. This will either be in the form of a simple slider control to make the changes, or be in the more complex form of a graph which can be altered on screen. Retouching tools will include pencils, paintbrushes and airbrushes, which can all be filled with a huge range of tones and colours, and adjusted in both size and character. One particularly useful tool to look out for is the clone or rubber stamp tool, which is used to copy an area of an image exactly and clone it elsewhere – it will prove very useful for retouching large blemishes.

Most software will allow you to remove the colour from an image and then add a tone such as sepia or other colour. Also, black-and-white images can be coloured by applying paint with a brush. The density, opacity and character of the colour can usually be altered so that all the detail from the original can still be seen.

Special effect and enhancement filters will be found in most programs – some will contain well over 100! These range from blur and sharpen filters, to artistic

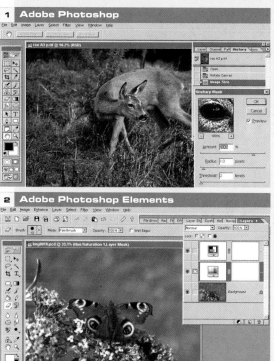

1 Adobe Photoshop

1/ Photoshop is the current 'industry standard' image-processing software. It has a huge range of enhancement and effects tools, as well as facilities for producing images for reproduction in books and magazines. The screen shows the toolbox, unsharp mask filter being applied, and the history facility, listing all of the operations carried out to the image during the working session.

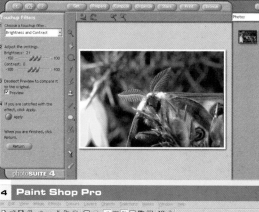

2 Adobe Photoshop Elements

2/ Elements is a 'cut down', cheaper version of Photoshop, but still contains probably all of the facilities required by the beginner and more advanced worker. Note the slightly different range of tools and the layers palette, with two adjustment layers, for levels and colour.

3 MGI PhotoSuite

3/ MGI PhotoSuite has a different screen layout. Shown here is the brightness and contrast control.

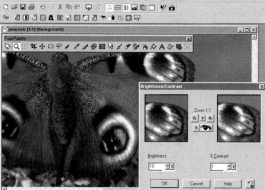

4 Paint Shop Pro

4/ Paint Shop Pro is a very comprehensive program with a very large user base. Note the range of tools and icons for performing various other operations.

effects such as pencil, charcoal or watercolour painting, to geometric distortions or lighting effects. They can be fun to experiment with, but be careful not to overdo them.

Look out for the feature to create layers. Different images can be floated on top of each other and combined to make the final image. Each layer can be adjusted, allowing total control over the creative process.

Various other programs are available, either as add-ons to the main program, or for specific purposes. These include programs for making intricate masks (Corel KnockOut) or producing bizarre manipulations (e.g. Goo). One particularly popular one is KPT (Kai's Power Tools) which features a large range of extra filters, as well as facilities like a texture generator.

2 clone tool [copy] **3** clone tool [paste]

! **Clone tool** – click on the tool, and select a suitable size (just like a brush). Select the area to be cloned or copied by holding the ALT key, and clicking with the left-hand mouse button. Now move the tool to the area where you want to place the cloned pixels and click the mouse button. Use it like a spotting brush, or paint larger areas as though it were a paintbrush.

tools, palettes and menus

tools

Different programs will have different ranges of tools, often called by different names! Some of the most common are described and illustrated here.

A range of painting and drawing tools – pencils, paintbrushes or airbrushes can be chosen. These are filled with a selected colour or tone. Usually the characteristics of the tools can be adjusted in terms of their size, shape and softness.

1

marquee
lasso
cropping
custom shape
airbrush
bucket fill
eraser
blur
sponge
red eye brush
clone stamp
hand
foreground colour
background/foreground colour toggle

move
magic wand

Horizontal Type Tool T
Vertical Type Tool T

gradient
paintbrush
pencil
impressionist brush
sharpen
smudge
dodge
dropper/sampler
zoom
switch colour
background colour

In most programs, the tools are accessed from a toolbar [1]. Clicking once on the tool selects it. Some offer a pull-down menu of options – note the little arrow next to the tool icon.

Clicking on some tools like a brush or pencil may display a range of options, such as the brushes palette [4]. You can select the shape and size of brush, as well as a range of other options such as opacity or mode. These determine how the paint is laid down on the image.

Possibly the most useful tool for retouching work is the clone, or rubber stamp tool. This can be found in most programs, and allows you to select an area of the image, and produce an exact copy, or clone, of it somewhere else. In the example shown, the cloning tool has been used to remove a small blemish from an area of skin in a portrait [2/3].

! Clicking on some tools like a brush or pencil may display a range of options, such as the brushes palette.

Rubber – The rubber, or eraser tool, removes areas of the image back either to white, or to an underlying image.

Cloning – The cloning tool is one of the most powerful tools. It copies, or clones an area of the image and places it in another area. It is useful for retouching, but also for adding areas of background or sky.

Selection – This tool selects an area, which becomes the active part of the image. The active selection will be affected by whatever changes you make. There are usually rectangular, circular or elliptical selections, or freehand lasso selections that are drawn with the mouse.

Cropping – The cropping tool is like a pair of scissors, removing unwanted parts of the image.

Text – The text tool is used to add text to images. In some programs, such as Photoshop or Elements, it is very powerful – the text can be rotated, warped or coloured.

Zoom – This is used to zoom in or out of an image, to enable close retouching, or to examine the fine detail of an image.

1/ <u>Toolbar</u> from Adobe Photoshop Elements.

2/ <u>Clone tool</u> showing area being cloned or copied using the <u>alt/click command</u>.

3/ <u>Clone tool</u> showing area once retouched.

4/ <u>Brushes palette</u> from Photoshop Elements.

5/ <u>Colour picker</u> in Photoshop Elements.

6/ Colour picker in Photoshop Elements showing <u>web-safe</u> option selected.

! Check your instruction manual for keyboard shortcuts which can save you hours. Set yourself a challenge to learn one each time you work on an image and you will soon find that they become automatic.

brushes

All imaging programs will have a range of painting and drawing tools – <u>pencils</u>, <u>paintbrushes</u> or <u>airbrushes</u>. Usually the characteristics of the tools can be adjusted in terms of their <u>size</u>, <u>shape</u> and <u>softness</u> and then they can be <u>filled</u> with a <u>colour</u> or <u>tone</u>.

In most programs, clicking once on the tool in the toolbar selects the tool and displays the range of options, such as the brushes palette. The <u>brushes palette</u> enables you to select the type, size and hardness of your brush or pencil [4]. Notice the range of <u>shapes and sizes</u> available, as well as other <u>options</u> such as <u>opacity</u>. The <u>mode</u> in programs like Elements, or Paint Shop Pro, refers to how the paint is laid down on the image. For example, <u>normal mode</u> applies colour like a *real* paintbrush, whilst <u>colour mode</u> applies colour in direct proportion to the colour of the pixels underneath. So, when applying a green colour, for example, light grey pixels would become a light green, and dark grey pixels would become a dark green. This is useful when hand-colouring an image, to retain all of the detail and just change the colour of an area.

colours

Whenever you pick a <u>brush</u>, <u>airbrush</u>, <u>pencil</u> or <u>bucket tool</u>, that tool will automatically be <u>filled</u> with the colour shown at the bottom of the toolbox. This can be altered in two ways. Firstly, you can <u>select a colour</u> from within the image, using the <u>dropper</u> or <u>sampler</u> tool. Clicking anywhere in the image places the colour from that spot into the <u>foreground</u> colour box.

Another way is to <u>double click</u> on the foreground <u>colour palette</u>, to bring up the <u>colour picker</u> dialog box [5]. Here you can use <u>sliders</u>, or <u>type in numbers</u> to select a colour. <u>Dragging</u> the small white circle around the area alters the <u>brightness and saturation</u> of the colour. Notice the box at the bottom for displaying <u>web-safe</u> colours. As discussed elsewhere, when designing web pages you should use a smaller range of colours to ensure that they look the same on all types of computer. <u>Clicking</u> on the <u>web-safe box</u> shows a much smaller range of colours from which to choose [6].

75091

All imaging programs allow adjustment to the brightness, contrast, colour balance and colour saturation of images. These adjustment controls range from simple sliders to more complex graphs.

Brightness: +17

Contrast: 0

OK
Cancel
Help

☑ Preview

menus and dialog boxes

There are a number of ways to work with your software program. In addition to your toolbar, handy palettes with brushes, colours, and layers can be opened and placed on the side of your desktop. The pull-down menus reveal choices and you select the feature you want. Selecting an item from a menu usually opens a dialog box. These work in a number of ways – some by typing in a number, others by clicking on the arrows and sliding them in one direction or another or moving the points on a graph. Often there will be more than one way of using them and you use whichever you find easier, more intuitive or more precise.

2 no feathering

3 feathered

4 feather selection

Feather Radius: 10 pixels

OK
Cancel

The pull-down menus allow you to select a range of operations to be applied to an image. Shown above is the brightness and contrast dialog box of Photoshop Elements [1]. The adjustments are achieved by clicking on the arrows and sliding them in one direction or another. You can also type a figure into the box on top of the scale. In this case, I wanted to lighten the dark area of the bird at the bottom left-hand corner of the image. I selected the lasso tool from the toolbox, which allowed me to draw a freehand selection around the area to be modified. I then moved the brightness slider to the right until the image appeared better balanced.

In order to ensure that the altered area merged seamlessly with the rest of the image, I feathered the selection. This puts a soft edge around the selected area as shown in the illustration. The amount of feathering can be altered – usually a figure of around 3–5 pixels should be sufficient, but you will need to experiment. This will also help if you are combining several images together – it is much easier to

combine elements if they have soft edges [2/3/4].

Most programs offer the facility of removing all of the colour from an image, and perhaps replacing it with a tone such as sepia to create an old-fashioned effect, as seen in Luzette Donohue's *Old Car* on page 54.

1/ The original bird image is shown on the left. The adjusted image on the right shows the selected area with the brightness increased.

2/ The fish with no feathering.

3/ The fish with feathering.

4/ Feather selection dialog box showing a radius of 10 pixels selected to soften the area around the fish.

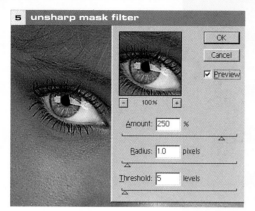

5 unsharp mask filter

5/ Unsharp mask dialog box.

6/ Filter preview window – Filters are a feature of all image-processing programs. The preview window shows the effect of the filters. See filter effects on page 78.

7/8/ The layers feature is a very powerful one. Here, an image is shown before [7] and after [8] a retouching exercise with several layers. The bottom layer is the original image, whilst the one above it is a copy of the image where the white tree behind the deer has been retouched out. The two top layers relate to changes in brightness and saturation of colour. You can turn off layers by clicking on the eye symbol on the left-hand side.

filters

Another type of dialog box will be found for the various filters. In the one shown here, for the unsharp mask filter [5], the adjustments are again made with sliders, whilst a preview button can be checked to see the before and after effect of the filter.

All programs will have a range of filters, and often there is no short cut but to try them with your image. Some programs, such as Adobe Elements, have a preview showing the effect of the filter [6].

layers and channels

Layers are like sheets of glass containing other images, or areas of retouching, or even just information relating to a change in density or colour, for example. They can contain masks that prevent selected areas of the underlying image from being affected by other changes. They are a very powerful feature and well worth having in a software program [7/8].

All coloured digital images are composed of channels, usually red, green and blue, which, when combined give the full range of colours. Changes can be made to each individual channel, as in Daniel Lai's example on page 90 of *Gondolas*, where he has applied various effects to individual channels to create a unique effect.

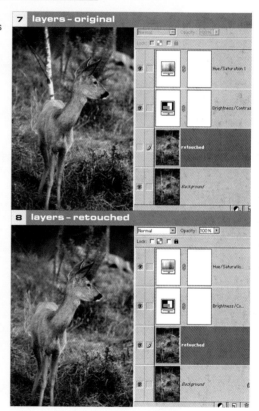

7 layers – original

8 layers – retouched

6 filter preview

Original 3D Transform Accented Edges

Add Noise Angled Strokes Bas Relief

Blur Blur More Chalk & Charc...

Charcoal Chrome Clouds

You can use digital image processing to enhance, manipulate or create new images. Most people will want to start by making subtle improvements to images. This example shows how a range of fairly simple techniques can be used to improve a poor image. All of the techniques shown here are discussed in more detail later in the book.

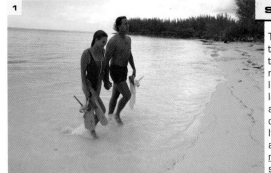

shoot

This image [1], by Don Cochran, is typical of many 'holiday snaps' taken quickly to capture the moment. Unfortunately, the lighting is poor – flat and dull – leading to washed-out colours and a pale sky. Also, the horizon is crooked, which is very distracting. It was shot on colour negative film and scanned in a film scanner at a resolution of 1000 ppi giving a file size of 4.5Mb.

first steps

enhance

The first step was to straighten the horizon. Adobe Photoshop and other programs have the facility to measure the angle of lines. I dragged the measure tool along the horizon and used the rotate > arbitrary command to straighten the image [2]. Rotating the image like this leaves some white space around the edges, so I used the cropping tool to remove this and to improve the overall composition.

The next stage was to improve the overall brightness and contrast. Many programs have an auto setting for this, good for beginners [3]. In this case it worked well, but beware, in some cases it won't, and you will find you need to perform this operation manually. The sky was still rather pale, so I selected it with the lasso tool [4] and adjusted this area separately using the brightness and contrast control. Before printing I applied an unsharp mask to the image, to increase the sharpness [see page 39].

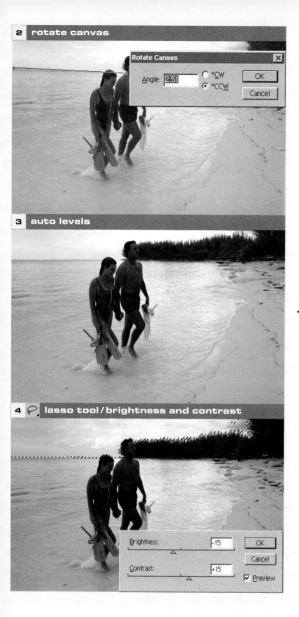

2 rotate canvas

Rotate Canvas

Angle: 2.51 ○ °CW ● °CCW

OK
Cancel

3 auto levels

4 lasso tool/brightness and contrast

Brightness: -15
Contrast: +15

OK
Cancel
☑ Preview

1/ The original image was rather flat, with dull lighting and had a sloping horizon.

2/ I dragged the measure tool along the horizon and used the rotate canvas command to straighten it by the amount measured by the tool.

3/ An auto levels command applied to the image improved the tonal balance and colour of the image.

4/ The sky area was selected using the lasso tool. The area was then adjusted using the brightness and contrast command.

5/ The image was re-sampled to produce a small file that could be used as an email attachment.

6/ The JPEG file to be emailed was only 22.65Kb.

share

I wanted two versions of the image – one as a print to send to the couple by post, the other to send them as an email attachment. The 4.5Mb was large enough to produce a 7 x 5in print on an ink jet printer at a resolution of 220 ppi.

I re-sampled the image in Photoshop to 6 x 4in at a resolution of 72 ppi, using the image size box, giving a file size of 351Kb [5]. I then saved this as a JPEG file on medium quality, which reduced the size to 22.65Kb [6]. This was small enough to send as an email attachment.

5 image size

Pixel Dimensions: 351K (was 4.47M)
Width: 432 pixels
Height: 277 pixels

Document Size:
Width: 6 inches
Height: 3.849 inches
Resolution: 72 pixels/inch

☑ Constrain Proportions
☑ Resample Image: Bicubic

OK
Cancel
Auto...

6 jpeg options

Matte: None

Image Options
Quality: 6 Medium
small file — large file

Format Options
○ Baseline ("Standard")
● Baseline Optimized
○ Progressive
Scans: 3

Size
~22.65K / 4s @ 56.6Kbps

OK
Cancel
☑ Preview

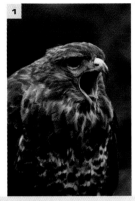

1

! Feathering – this gives a soft edge to a selection instead of a hard edge, rather like the difference between a piece of paper that has been torn rather than cut. Feathering a selection means that any alteration to that area will be faded out towards the edge.

! Lasso/freehand selection tool – allows you to draw a freehand selection around an area of the image that you want to modify or enhance. In this case a rough outline was drawn around the bottom left-hand corner of the image. This area, delineated by an animated line, becomes the active part of the image, which can be brightened, darkened, or have the contrast altered. Selecting areas with the lasso tool is a skill that comes with practice.

adjusting brightness and contrast

shoot

One of the fundamental operations of all image processing programs is to adjust the brightness and contrast. This is rather like adjusting the controls on a television set, the brightness altering the overall density of the image, whilst contrast determines the range of tones from black through to white.

Whilst it will sometimes be necessary to adjust the brightness and contrast of entire images, it may also be necessary to adjust only specific areas, perhaps to lighten shadows or brighten highlight areas.

Most programs have simple slider controls to alter the brightness and contrast.

This image of a buzzard calling to its mate was shot on slow speed (50 ISO) transparency film using a 300mm lens on a 35mm SLR film camera.

The weather was overcast so the image was flat and dull [1].

I wanted an A3 print for an exhibition, so I scanned the transparency in a high resolution 35mm film scanner at a resolution of 2700 ppi to give a file size of around 24Mb.

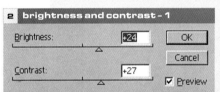

2 brightness and contrast – 1

Brightness: +24 OK

Contrast: +27 Cancel

☑ Preview

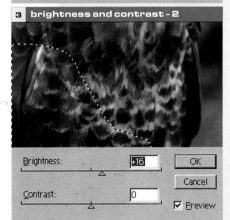

3 brightness and contrast – 2

Brightness: +16 OK

Contrast: 0 Cancel

☑ Preview

enhance

After loading the image into Adobe Photoshop I opened the brightness and contrast dialog box [image > adjust > brightness and contrast] [2] and moved the sliders until I got the effect I was after. I was careful not to make the image too bright or 'contrasty', or I would lose detail in the beak of the bird (the brightest part of the subject).

There were still two areas that I felt needed some attention. The first was the bottom left-hand corner which was rather dark. I drew a freehand selection roughly around the area, and applied a five pixel feather to the selection to soften the edges. I lightened this area with the brightness and contrast control [3].

The second area was the inside of the bird's mouth. This was still flat and lifeless. I carefully selected it using the freehand lasso tool [4], and enhanced the tone by increasing the saturation of the colour using the hue/saturation dialog box [5] [image > adjust > hue/saturation]. Again, I was careful to keep the effect looking natural.

To complete the image, I adjusted the overall colour balance [image > edit > colour balance], adding a small amount of green to it.

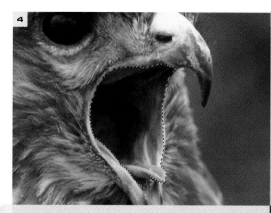

4

1/ The original image of the bird is flat and lifeless.

2/ The <u>brightness and contrast control</u> has been used to modify the whole image.

3/ The bottom left-hand corner of the image has been selected with the <u>lasso tool</u>, and the <u>brightness</u> of this area modified.

4/ The bird's mouth has been selected with the <u>lasso tool</u>.

5/ The <u>saturation</u> of the colours inside the mouth have been increased.

5 hue / saturation

Edit: Master ▾

Hue: ⬚0

Saturation: +34

Lightness: +6

OK
Cancel
Load...
Save...

☐ Colorize
☑ Preview

share

Before printing I applied an <u>unsharp mask</u> of 200%. The image was printed to <u>A3</u> size on an <u>ink jet printer</u> at a resolution of <u>220 ppi</u>.

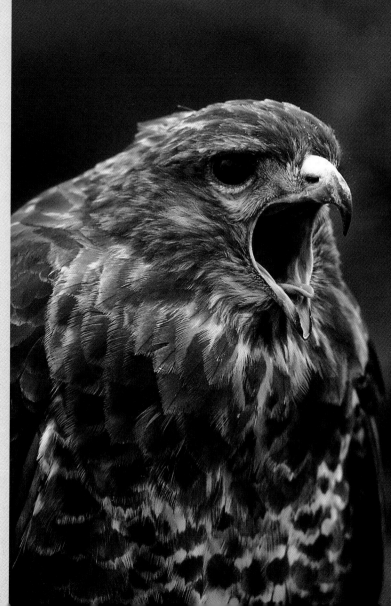

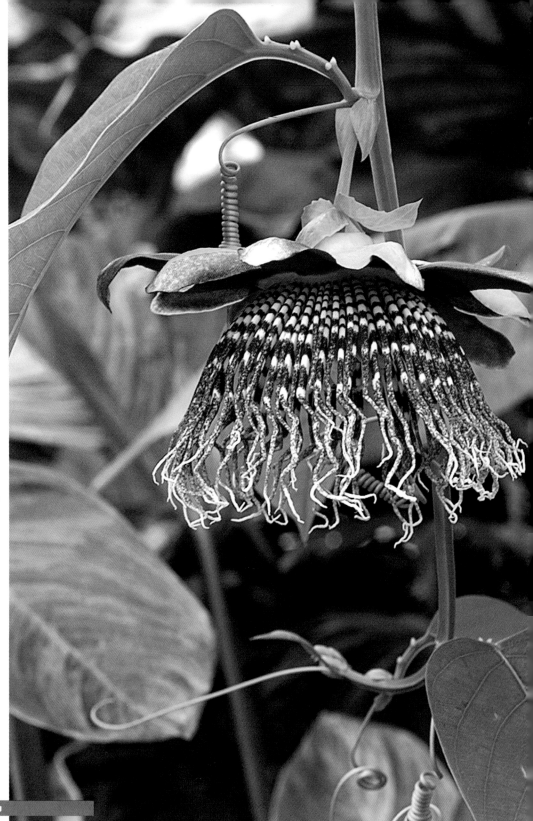

Most digital images, whether created with a scanner or digital camera will need to be sharpened. The reasons for this are primarily due to the sampling process of the **CCD** sensor used in the digitisation process. Most imaging programs will have a range of sharpening filters – sharpen, sharpen more and the unsharp mask being the most common.

An important factor with sharpening is that different types of image, scans or digital camera may need different amounts of sharpening, as will images of different subject matter. A soft-focus portrait will need a completely different amount of sharpening to a highly detailed still life. For this reason, if your software program has one, use the unsharp mask filter for all your work. The advantage of this is that it can be controlled very easily and can be adopted to any need.

! **The unsharp mask filter –** This unfortunate name is derived from an old printing technique where an unsharp version of a negative was sandwiched with the original to give a sharper result!

! **The unsharp mask filter –** The settings are important for picture quality. **Amount** – governs the overall degree of sharpening. **Radius** – determines the amount around the edges within the image that is affected by the filter. A high amount makes edges thicker. **Threshold** – specifies the difference in lightness values that adjacent pixels must have before they are sharpened.

sharpening your image

shoot

I <u>shot</u> this passionflower on a <u>3 megapixel digital camera</u> in a glasshouse at a botanic garden with natural light [1]. Many digital cameras offer the option of sharpening *in camera*. For most purposes it is best to turn this option off and perform all sharpening in your image-processing program.

1/ The original image.

2/ The <u>unsharp mask filter</u> in Adobe Photoshop showing adjustable settings and preview window.

3/ The image has been over-sharpened and has lost detail.

enhance

Using Photoshop, I adjusted the <u>brightness and contrast controls</u> to give a good image on the screen. The image was then magnified to 1:1 and the <u>unsharp mask filter</u> dialog box selected [filters > sharpen > unsharp mask] [2]. The box has three controls: <u>amount</u>, <u>radius</u> and <u>threshold</u>. Use low figures for the radius and threshold – in the region of 1 or 2 – and the amount 150–200% for most digital camera images. Do some tests, producing two or three versions of the same image with different settings, and see which you prefer.

Don't rely on the image on the monitor to see the effect – print out the images to get the best idea.

share

I wanted to produce a <u>high quality</u> image for display in a botanic garden. It was printed on <u>photo quality glossy film</u> at high definition.

! Make sharpening the last operation before printing, particularly if you have re-sized the image. If your images are for publication, then printers may add their own sharpening, so check first! Always keep a copy of your images unsharpened.

Be careful not to overdo this filter. It is very apparent when an image has been over-sharpened, looking more like an engraving than a photographic image!

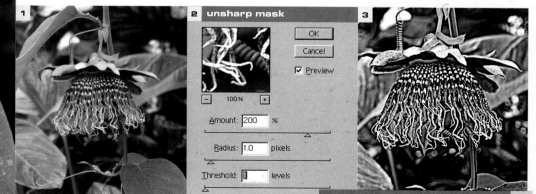

'I wanted to blur the background as parts of it were too sharp, but I didn't want to lose the effect of a natural setting.'

! By selecting different areas of the background, you can apply different amounts of blurring to create a realistic depth-of-field effect.

! Try to use filters that can be adjusted like the gaussian blur, or unsharp mask. This gives you much more control over the final effect. Alternatively try a standard blur filter and apply it more than once to certain areas.

depth-of-field

Depth-of-field is the amount of the subject that is in focus, in front of and behind the main point of focus. In cameras it is controlled by the lens aperture. The smaller the aperture (i.e. the higher the number) the more depth-of-field. It can be used to isolate the subject against an out-of-focus background, or to bring a group of subjects into sharp focus. Used carefully depth-of-field can help you make distracting objects in the background out of focus.

Many compact digital cameras won't allow you to manually control the lens aperture, with the result that the depth-of-field may not be ideal for the subject.

But digital image processing does allow you to control the amount of sharpness, by selectively sharpening or blurring areas of the image.

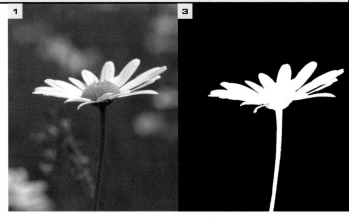

shoot

This image of an ox-eye daisy was taken in an English wild flower meadow in May, using a 3 mega-pixel digital compact camera. The zoom lens was set to its longest setting, and the camera set to macro mode so it would focus on the flower [1].

enhance

I wanted to isolate the flower, so I gradually selected it using the magic wand tool in Paint Shop Pro [2]. By trial and error I found that a setting of 10 worked best for the tolerance. This selected a small piece of the flower. By holding the shift key down and clicking the wand again, more of the flower was added to the

selection until the whole flower and stem had been selected. I saved this selection as an alpha channel and called it 'flower', so that if I wanted to refer back to it in the future I would know what was in the alpha channel [3].

Next I inverted the selection [select > invert] – so that it was the background that was selected, not the flower – and applied a gaussian blur filter which blurred the background behind the flower. This filter is adjustable and I tried various settings until I got the effect I was looking for [4].

Saving a selection: If you have spent some time making a selection, save it for future use. In Paint Shop Pro, use [selections > save to alpha channel]. You will be asked to give the channel a name: this channel can then be loaded into the image at any time when it is needed, to re-activate the selection.

The main part of the subject may need to be sharpened before printing. The amount you sharpen will depend on a number of

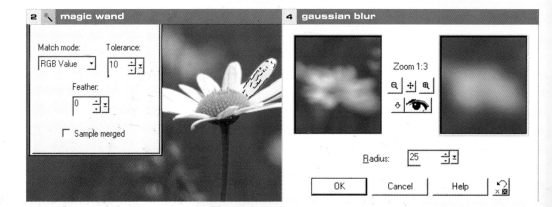

! **To modify your selection –**
Hold down the <u>shift key</u> to
add to the selected area.
Hold down the <u>alt key</u> to
remove parts of the selection.

factors (see page 38) but again,
different parts of the image can
be sharpened by different
amounts. If your software has an
<u>unsharp mask filter</u> use this, if
not, then the sharpen filter can be
applied more than once for
different amounts of sharpening.

share

I wanted to use this image as the
basis for a personalised greetings
card, and printed it on to a
heavyweight ink jet cartridge
paper at a resolution of <u>220 dpi</u> in
a <u>photo quality ink jet printer</u>. I
printed it to A5 size (approx.
14.75 x 21cm) on the right-hand
side of the A4 paper, so that it
could be folded into a greetings
card. Later, I added the text to
complete the card.

1/ The original image.

2/ The <u>magic wand</u> tool has been
used to <u>select</u> the flower and stem.

3/ The <u>selection</u> saved as an
<u>alpha channel</u>.

4/ Applying blurring to
the background.

1/ The overcast sky makes the original image look flat.

2/ The magic wand tool in Photoshop Elements has been used to select the sky. Notice the view through the window has been selected as well.

3/ The rocks have been selected, and the contrast adjusted independently from the rest of the image.

improving bad weather

There will be many occasions when you have travelled to a photogenic scene, only for it to look dull due to the weather – perhaps the sky is overcast, or the light is coming from the wrong direction. Digital image processing can be used to great effect, to enhance an otherwise poor image.

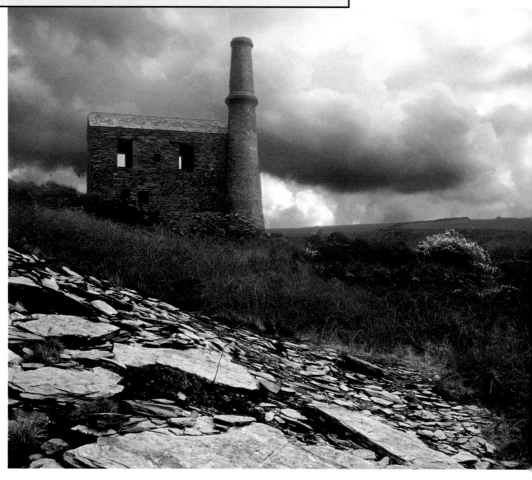

'I wanted to capture the eerie and lonely feeling of this place – so introduced a heavy sky – and maintain the almost monochromatic effect of the original image. The intention, at the time of shooting was to add a more interesting sky, and to enhance the tones within the image to produce a more dramatic effect.'

shoot

This shot, by John Wigley, of a pump house in Cornwall was almost monochromatic due to the poor weather conditions. The sky was uninteresting and a dull blue colour [1].

share

I wanted the image for display in a digital photography exhibition. It was printed to a size of A3 on an ink jet printer at a resolution of 220 dpi on to a heavyweight textured art paper.

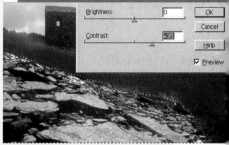

3 brightness and contrast

Brightness:	0	OK
Contrast:	35	Cancel
		Help
		☑ Preview

enhance

The first task was to introduce a dramatic sky, taken in another location.

I used the magic wand tool in Photoshop Elements, starting with a tolerance setting of 16 to select the sky [2]. This setting means that any pixels within a density or colour value of 8 on either side of the wand will be selected. This was not sufficient to select the whole sky, so, holding down the shift key, new areas can be added to the selection until the whole area is selected. Once the selection was complete, I copied the sky, and used the paste into command to paste it into the image. This puts the sky only into the selected area, and not into the rest of the image.

Keeping the sky area selected, I darkened it using the brightness and contrast controls [3].

The rocks in the foreground were lightened to give a greater sense of depth.

Then, the saturation of the colours of the yellow gorse and vegetation was increased, to add interest.

There are several ways of enhancing different areas of an image. Elements, along with other programs, has burn and dodge tools, in effect brushes which lighten or darken areas as you paint over them. However, these do not allow you to control contrast as well, so I prefer to make selections, and then adjust these using the brightness and contrast, or hue/saturation controls. Use a fairly high feather setting so that the modified area blends in.

In this case I selected the rock area, the gorse bushes and moorland areas separately to adjust them.

When I had adjusted each area independently, I looked at the image as a whole, and made small adjustments to the brightness and contrast to finish it off.

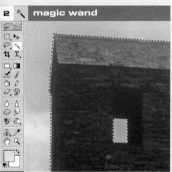

2 ✎ magic wand

retouching

first steps – dust and scratches

There are many reasons why digital images need retouching, but probably the most common is where the original photographic film or print has not been cleaned thoroughly before it was scanned. The resulting digital image then shows dust particles, or even scratches.

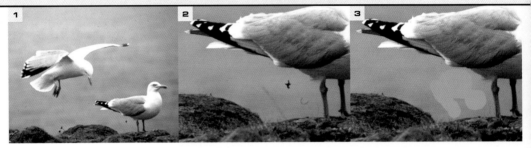

shoot

I scanned a dusty 35mm transparency at high resolution [2000 ppi] in a film scanner [1]. and a large number of dust particles are clearly visible, particularly in the sky area [2].

enhance

When you retouch conventional photographic prints, the basic technique is to mix a colour or tone of dye that closely matches the area surrounding the particles and use a spotting action to lay individual spots of dye over the dust particles. If you paint too large an area with the same colour it will be very noticeable [3].

The same technique can be used with digital imaging, but make sure that you re-sample the colour frequently to avoid an area containing pixels of the same value.

As you can see in the illustration, even a seemingly even background is composed of pixels of different values. A much better method is to use the cloning tool found in most imaging programs.

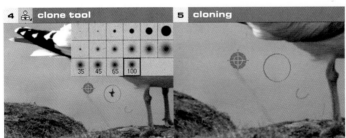

4 clone tool 35 45 65 100

5 cloning

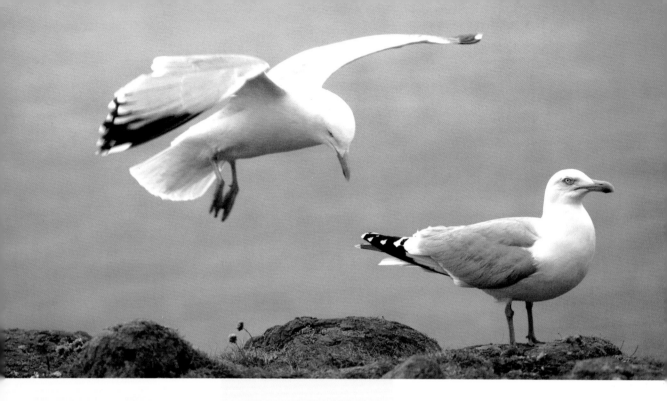

6 dust & scratches

OK

Cancel

☐ Preview

− 100% +

Radius: 1 pixels

Threshold: 0 levels

7 dust & scratches

OK

Cancel

☐ Preview

− 100% +

Radius: 5 pixels

Threshold: 0 levels

share

Before printing, the image will need sharpening. Make sure this is the last operation you carry out before printing, as you need to make sure that all areas of the image are sharpened to the same degree. In this case an A4 image was needed for display in a nature reserve exhibition.

1/ The original scanned image, showing dust particles in the sky and sea areas.

2/ Close-up of dust particle.

3/ This is an example of poor retouching because the area has been painted with one colour.

4/ The clone tool in operation showing source and destination. Note dialog box to select tool size.

5/ The clone tool has replaced the dust particle with an area of the sea.

6/7/ Dust and scratches filter – see tip.

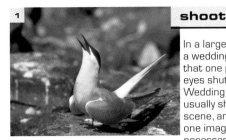

In a large group of people, such as a wedding party, it is very possible that one person will have their eyes shut at the crucial moment! Wedding photographers will usually shoot two images of this scene, and clone the eyes from one image to another if necessary. In a similar vein, many birds have black heads and black eyes. If there is no catchlight in the eye to highlight it, then the whole image appears dull. Many bird photographers use small flashguns to add that important catchlight.

In the example shown here, the tern was caught in action calling for its mate, but wasn't quite at the right angle to get a reflection of the sun in its eyes [1/2]. I took several images at the same time and cloned the catchlight from one image into this one [3].

When you shoot portraits of people or animals, the most important area to get right is the eyes. Our eye immediately goes to the eyes in the image, and if these are not sharp, or cannot be seen, then the image starts to lose its impact.

enhancing eyes

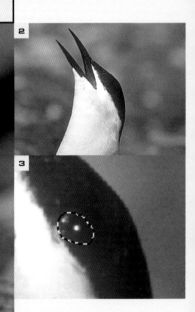

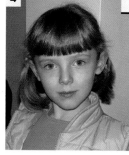

4

shoot

Red eye is a common problem. The effect is caused when you use a flashgun close to the lens axis. The flash hits the retina of the subject's eyes and is reflected back off the red blood vessels. The simplest way to avoid it is to separate the flash from the camera, but this is not always possible with compact cameras.

The <u>shot</u> of Beth by John Wigley was taken on a <u>compact type digital camera</u>, the Nikon Coolpix950, using the <u>on-camera flash</u>. The red eye effect is particularly obvious [4].

enhance

The principle is to select the area of red within the eye, then to re-colour it the right colour. You can do this <u>manually</u> but many programs, such as MGI PhotoSuite, and Paint Shop Pro have <u>automatic red eye reduction</u> facilities [5].

The screen shot below shows the <u>red eye removal dialog box</u> – [effects > enhance photo > red eye removal]. The <u>freehand pupil outline option</u> was selected, this allows you to manually select the area to be corrected [6]. This is useful if part of the eye is obscured. (There is also the option for animal eyes as well in this box). You can adjust the lightness of the pupil, alter the size of the glint in the eye, and the colour. Experiment with various colours and settings to achieve a natural effect.

To complete the image, the background was <u>tidied</u> up by <u>cloning</u> the colour from <u>the central area over the rest of the background</u>, then applying a lighting effect found in [effects > illumination > lights], where the effect of one or more lights can be simulated.

1/ The original photo of the tern.

2/ The tern's black eye and black head merge together with no catchlight.

3/ A catchlight from another image has been <u>pasted</u> in.

4/ Red eye caused by a standard flash.

5/ Red eye removal in Paint Shop Pro – note the settings for <u>freehand pupil outline</u>, and <u>glint lightness</u>.

6/ The red eye area selected with the <u>magic wand tool</u>.

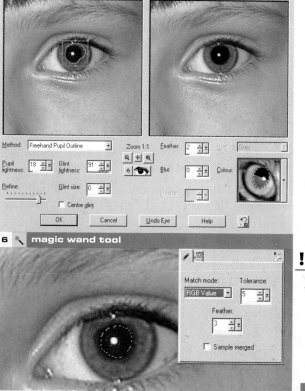

5 auto red eye removal

Method: Freehand Pupil Outline Zoom 1:1 Feather: 2 Hue: Grey

Pupil lightness: 18 Glint lightness: 91 Blur: 0 Colour:

Refine: Glint size: 0

☐ Centre glint

OK Cancel Undo Eye Help

6 magic wand tool

Match mode: Tolerance:
RGB Value 5

Feather:
3

☐ Sample merged

! If you have a photograph of the subject without the red eye effect then you can sample the colour from that one.

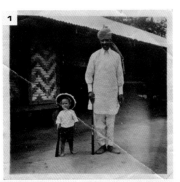

! Always handle old photos with great care. They will often be fragile and may tear easily at any creases.

restoring an old photo

shoot

Many families will have old photographs that are creased, torn or faded. Digital imaging allows a much greater ability to restore old photographs to their former glory.

Firstly I needed to digitise this old photograph by scanning it in a flatbed scanner [2]. I scanned the 90 x 90mm print at high resolution (600 ppi) to cover all eventualities of size. This yielded a 13Mb file, large enough for at least a 10in print. The aim was to produce a digital print to frame and several smaller prints to hand out to relatives. I deliberately left the original border on the image to use in the final print [1].

enhance

I opened the image in Adobe Photoshop Elements and saved it as a TIFF with the name 'Original'. Later versions would be given sequential numbers. It is essential to retain the original untouched as an archive.

I decided to remove the colour by converting it to greyscale mode [image > mode > greyscale] and replace the colour afterwards. This meant that I was only working on a 4Mb file rather than the colour 13Mb one [3].

Using the magnifying glass, I enlarged the area to be worked on [4]. The clone tool was used for most of the retouching. This duplicates, or clones, a designated source group of pixels over another group. In this way a scratch or tear can be filled with a pattern of pixels so that the two areas match. A soft-edged clone brush was selected and the source area defined by alt-clicking with the mouse button. The brush

was now moved to the area to be filled, and the left-hand button of the mouse depressed whilst painting with the brush.

This will take some practice. Be careful to avoid repetitive patterns by re-sampling the source area [5].

The most difficult areas were the boy's face, and the ground as the fading was uneven. Zooming in to a high magnification on the face meant that this area could be retouched carefully.

Finally, I wanted to restore the sepia tone colour. I opened the original file, and sampled the colour of the shirt with the eyedropper tool [6]. This colour becomes the foreground colour in

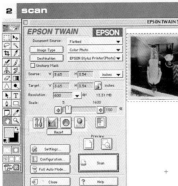

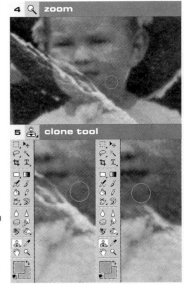

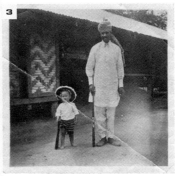

6 ✎ sampling

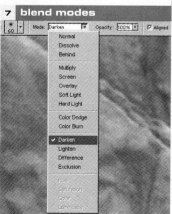

This <u>colours the pixels</u> in proportion to their original value – light grey pixels take on a light colour, and darker pixels take on a correspondingly darker colour. This gave an almost exact replica of the original. I finished by adjusting the <u>brightness and contrast</u> before printing.

share

The aim of this exercise was to produce a faithful replica of the original print, which was on a matt surface ink jet paper. The image was <u>not sharpened</u>, so that it retained the <u>slightly soft feel</u> of the original. I made an <u>A4 print</u>, at a resolution of <u>200 dpi</u> on my <u>ink jet printer</u>, then several <u>smaller</u> versions for the family.

1/ The original image.

2/ Screen shot of <u>scanner interface</u> showing scan resolution, mode, and final file size.

3/ Image converted to <u>greyscale mode</u>.

4/ Close up of image area showing damage. <u>Clone tool</u> selected.

5/ <u>Clone tool</u> next to damaged area.

6/ Sampling the colour of the original with the <u>eyedropper tool</u>.

7/ <u>Blend modes</u> in Photoshop Elements, showing darken mode selected.

8/ <u>Fill box</u>, showing options for filling image with the foreground colour.

the palette at the bottom of the toolbox. I then converted the retouched image back to colour mode [mode>RGB colour] and <u>filled</u> it with this colour using the <u>blend mode colour</u> [edit>fill> foreground colour>colour] [8].

8 fill

Contents
Use: Foreground Color
Custom Pattern:

Blending
Mode: Color
Opacity: 100 %
Preserve Transparency

OK
Cancel
Help

7 blend modes

colour and monochrome

1/ The original image.

2/ The sepia toning control in Paint Shop Pro. Alternatively you can change the colour of the tone with a dialog box for hue, saturation and brightness.

sepia toning

Many old photographs are sepia toned – indeed one of the reasons they have lasted so long is the chemistry used in the sepia process. Digital imaging programs can be used to remove colour from modern images, then tone them in sepia (or any colour). Luzette Donohue shows here how to take a very ordinary photograph and turn it into an evocative sepia tone print.

shoot

I shot this rather mundane image of a vintage car on colour film at a vintage car rally, with the idea of transforming it into an evocative picture with a feel for both the 1930s together with a very contemporary style. I wanted to retouch the distracting sign on the front radiator grill and blur the background figures to create a shallow depth-of-field effect [1].

I scanned the image in a slide scanner at a resolution of 2000 dpi, giving a file size of 18Mb. I cropped it to the final shape using the cropping tool in Paint Shop Pro.

enhance

To blur the distracting background, I drew a selection around the background with the freehand selection tool, and applied a soften filter. Alter the effect of this to suit the subject.

I retouched the sign on the radiator grill with the cloning tool. This tool copies, or clones, selected areas of an image to another area.

The final stage was to give it an old fashioned look with a sepia tone. Some programs have a sepia tone option, whilst others allow you to change the colour of the tone with a dialog box for hue, saturation and brightness.

In this case, I used the sepia option [effects > artistic > sepia] set to its maximum setting [2].

share

I printed the image on to a textured ink jet paper and framed it in an 'antique style' wood picture frame to enhance the atmospheric feel of the image.

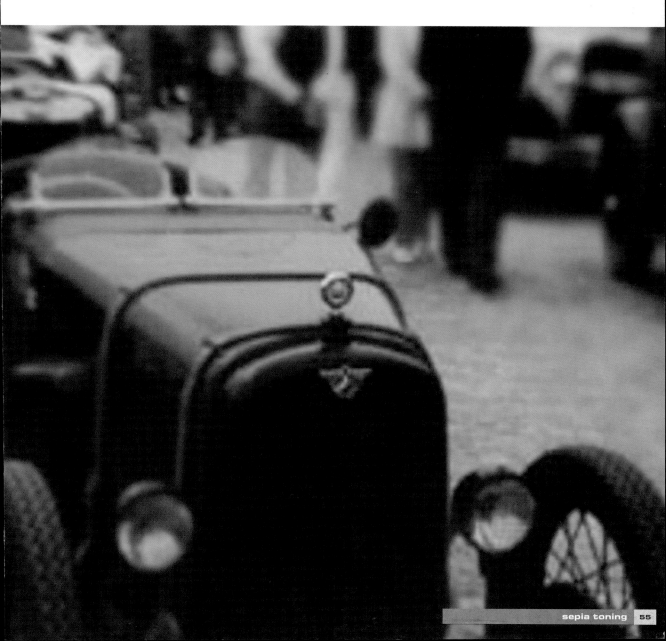

1/ The original image had a very warm tone due to the soft tungsten lighting used for the shot.

2/ The rose has been selected with the magic wand tool.

3/ The hue/saturation dialog box showing a change of hue towards blue, and a de-saturation of the colour.

split toning

shoot

enhance

share

Selectively removing the colour from areas of an image and enhancing other areas can improve the impact of an image greatly. In this example, by Walter Spaeth, the warmth of the skin tones has been reduced, whilst the saturation of the red rose has been increased, creating contrast between the figure and the rose.

I shot this image on film using soft tungsten lighting to give a very warm effect to this nude study. I scanned the transparency at a resolution of 2000 ppi to give an 18Mb file [1].

Enhancing the image was a fairly simple process. The first step was to select the rose with the magic wand tool [2]. I set the tolerance to a small setting so that the selection did not spill over to the background. I then inverted this selection so that it was the rest of the image that was selected, not the rose. By experimenting with the hue/saturation controls, I found a tone of blue that seemed to suit the effect I was after [3]. I now re-inverted the selection [select>inverse], and increased slightly the saturation of the rose.

The image was intended for display in a photographic club exhibition. I printed it to a size of A3 on to a matt surface ink jet paper.

1

Edit: Master ▲▼

Hue: 200

Saturation: 25

Lightness: 0

OK
Cancel
Load...
Save...

☐ Colorize
☑ Preview

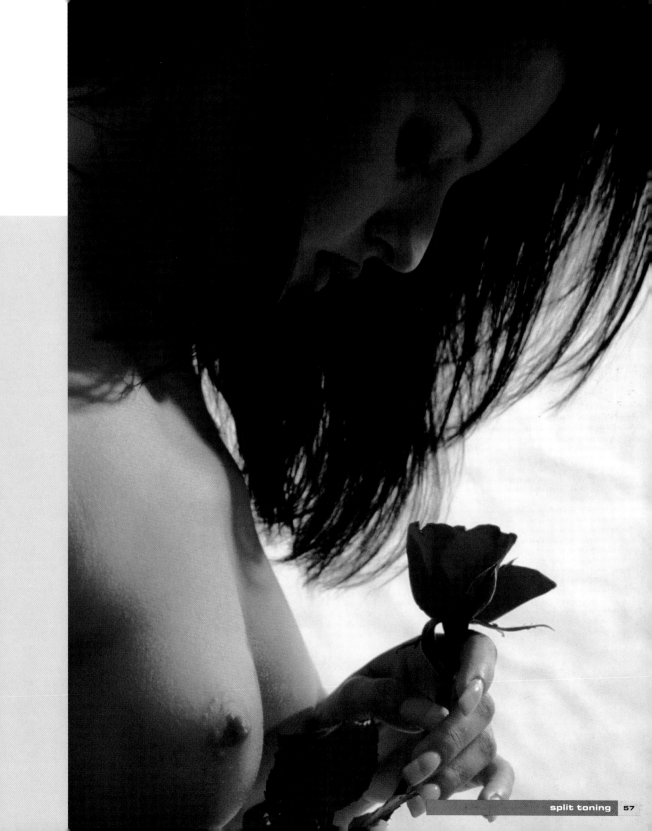

'This type of "painting" satisfies the artist in me – small or large areas can be treated in this way, but planning is essential if the picture is to look right!'

! | Graduating colours – In the case of the sky, the effect of the fill was graduated using the gradient editor. In this case the colour was graduated so that it faded to transparency.

colouring photographs

There are basically two ways of adding colour to monochrome images. One is to paint the colour with a brush, a technique used by early photographers often for colouring portraits. The other is to fill selected areas of an image with colour.

Some scenes, such as bleak moorland in dull weather are essentially monochromatic, but can be used as the basis for producing coloured images to enhance, or alter the atmosphere of the original scene.

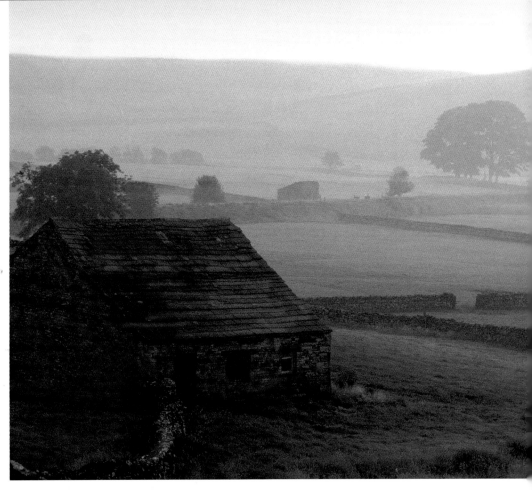

This image of Wensleydale in Yorkshire by John Wigley was <u>shot on film</u> at 5.30am on a grey, overcast morning, with the intention of adding colour to it later [1].

I <u>converted</u> the original colour image to <u>monochrome</u> to remove any trace of colour, using the <u>colorize</u> command in Paint Shop Pro, set to values of 0 and 0 for hue and saturation [2]. This is sometimes known as 'de-saturate' in other programs. Essentially, it removes the colour from tones, reducing them to a shade of grey. The brightness and contrast were then adjusted to produce a 'good' black-and-white image.

The next stage was to decide on a colour scheme for the image. The foreground grass and barn were easy, but choosing the right colour for the hills and sky took longer.

The basic technique here is to <u>select</u> the area to be coloured using the <u>freehand lasso tool</u>, with a <u>feathered edge</u> to soften the edge of the selection. I chose the colour in the <u>colour palette</u>, and then <u>filled</u> the selected area with the paint bucket in <u>multiply mode</u> [3]. The strength of the final colour can then be adjusted using the <u>opacity slider</u>, to give a much more pastel appearance.

I intended the print to be shown as part of a series for an exhibition of digital imagery. In this case it was printed on to a sheet of textured ink jet paper at A3 size.

1/ The original image.

2/ The <u>colorize box</u> in Paint Shop Pro – note the ability to preview the effect.

3/ Filling the selected area with the <u>flood fill</u> command, set to <u>multiply blend mode</u>. This multiplies the values of the underlying pixels by the fill colour.

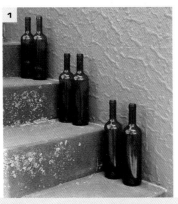

working with colour

Colour is an integral part of our world, but how we record it in photographs can lead to the success or failure of an image.

The same object or scene can have bright vibrant colours, or soft muted colours depending on the light conditions. You can use the digital image processing on your computer to increase or decrease the saturation of one or all colours within a scene. Combinations of colours are important too. Groups of colours, such as the reds, browns and yellows of autumn trees harmonise, whilst contrasting colours can produce striking lively images.

In some cases, such as a misty day, a scene will be virtually monochromatic, and it is your skill as the photographer to decide if this is the desired effect or whether you need to enhance the image.

This image by Sonya Cullimore demonstrates the use of bright colours within an image, enhanced by digital image processing.

shoot

The original concept for this image was to show the use of similar colour tones and how different textures can harmonise to form a visually interesting image. The contrasting yellow moss on the steps adds extra interest. The final image is now hanging on my living room wall as an 11 x 14in print, and is exactly how I first imagined it.

I shot the original image on a 2.5 megapixel digital camera, and transferred it from the SmartMedia card to the computer via a USB card reader [1].

enhance

I opened the image into Paint Shop Pro to enhance the colours. First, I brightened it and increased the contrast using the brightness and contrast controls [2]. Next, I used Paint Shop Pro's automatic saturation enhancement feature [effects > enhance photo > automatic saturation enhancement] to increase the colour saturation. The settings were arrived at by trial and error [3].

share

I wanted the image for my living room wall, and printed it on to glossy paper to enhance the colours further. I re-sized the 2.1Mb image so that I got a 14in print when printed at a resolution of 200 dpi on my ink jet printer. Before printing, I applied an unsharp mask filter to sharpen the image.

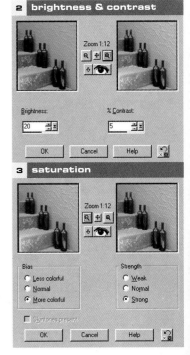

2 brightness & contrast

Zoom 1:12

Brightness: 20 % Contrast: 5

OK Cancel Help

3 saturation

Zoom 1:12

Bias
○ Less colorful
○ Normal
● More colorful

Strength
○ Weak
○ Normal
● Strong

☐ Skintones present

OK Cancel Help

1/ The original image.

2/ The image was dull and a bit flat so the brightness and contrast controls were used to add more light and increase contrast.

3/ Paint Shop Pro's automatic saturation enhancement feature was used to increase the colour saturation.

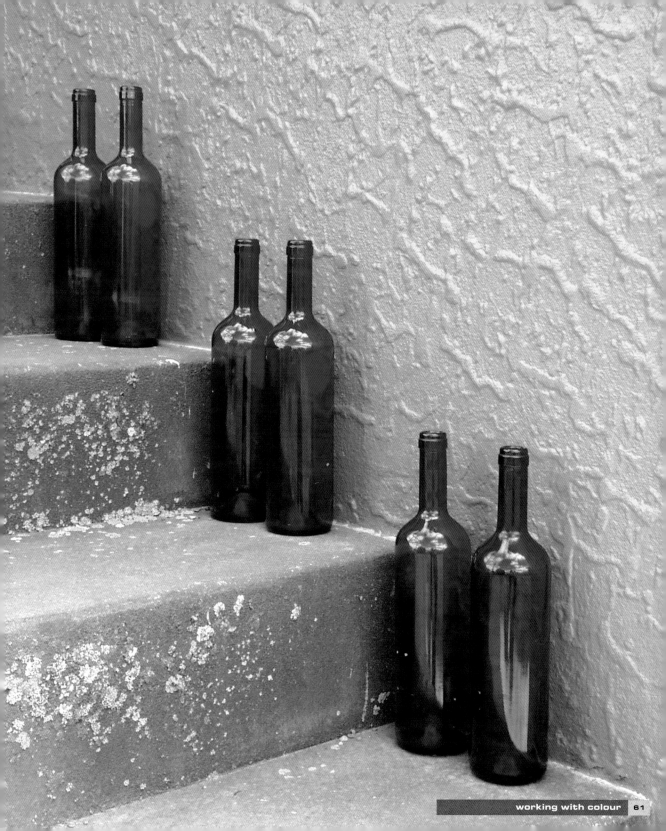

This second image by
Sonya Cullimore is an
example of being in
the right place at the
right time!

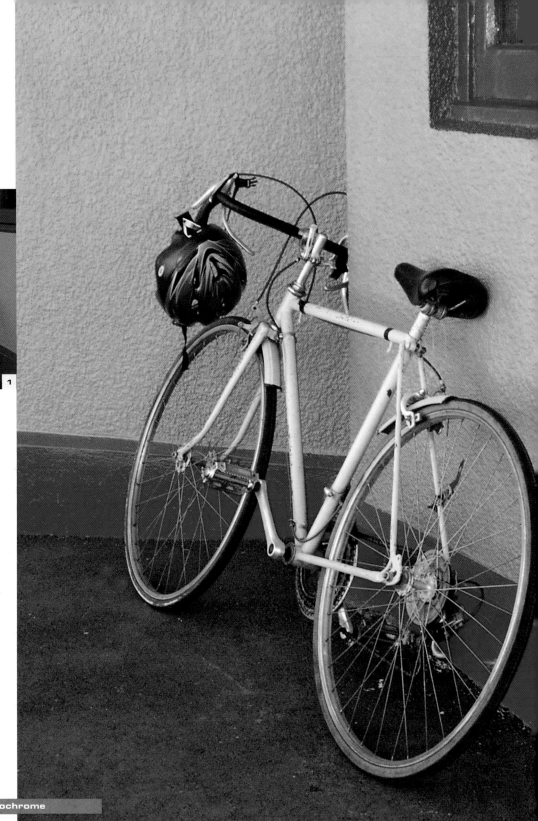

1/ The original image was rather dull and lacked contrast.

2/3/ The brightness, contrast and saturation controls were used to adjust the colours.

4/ The clone tool was used to remove some distracting objects on the floor. An area which was clean was selected and then used to paint over the unwanted area.

shoot

I was driving along when I saw this yellow bicycle leaning against the contrasting orange wall. I was immediately drawn to the combination of colours, the orange and yellow contrasting with the purple window frame. I stopped the car and grabbed my digital camera. I managed a series of shots before the owner of the bicycle came and rode off. Although this is an example of a 'found' still life, I couldn't have wished for a more striking image [1].

enhance

I used Paint Shop Pro to enhance the colours as well as retouch certain distracting features of the image. The original image was rather dull and lacked contrast, so I used the brightness, contrast and saturation controls of Paint Shop Pro to adjust the colours within this image [2/3]. When the image was brightened, a number of distracting objects became apparent on the floor of the scene. I used the cloning tool to remove these, using the settings shown on the screen [4].

share

This image was printed on an ink jet printer, and hangs in the living room near *Bottles*. I have also included it in on my website, where I have an online portfolio.

Colours of course don't need to be bright and saturated. Foggy or misty days which produce soft muted colours may not at first glance seem suitable for photography, but with careful enhancement they can lend themselves to striking imagery.

This image by Rod Edwards illustrates the use of soft muted colour to great effect.

'I used a <u>graduated blue filter</u> on the camera lens, but a similar effect could have been achieved in the computer using the <u>gradient</u> tool. I also used a clear <u>skylight filter</u> smeared with a small quantity of Vaseline to further soften the image.'

using colour for effect

shoot

I shot this image early in the day in the Cotswold Hills in southern England on a film camera. I used a 35mm slow colour transparency film with a zoom lens set to around 50mm. As the image was intended for commercial use I scanned the transparency at 2700 ppi giving a file size of 25Mb [1].

enhance

The crucial element to this image is the density. Too dark and it would lose the subtle tones, too light and it would be underexposed. I used the brightness and contrast controls in Photoshop to carefully adjust the overall balance of the image. It was particularly important that the transition between land and sky remained, and that the tree was still visible. If the image went too light the tree would be lost. Once I achieved the right balance, I adjusted the colours using the hue/saturation controls [2], increasing slightly the saturation of the blue colours within the image. Finally, I applied the film grain filter in Photoshop to enhance the mood of the shot. I tried various settings until the right amount was found [3].

share

The image has proved popular with fine art buyers – I've sold a number of copies as fine art exhibition prints, produced on high quality art paper on an ink jet printer.

2 hue/saturation

Edit: Master

Hue: 0
Saturation: 50
Lightness: 0

OK
Cancel
Load...
Save...

☐ Colorize
☑ Preview

3 grain

OK
Cancel

100%

Intensity 40
Contrast 50
Grain Type: Regular

1/ The original image was lacking in contrast and colour saturation.

2/ The hue/saturation dialog box was used to increase the blue saturation.

3/ Film grain dialog box – this filter can be adjusted and various settings were tried until Rod was happy with the result.

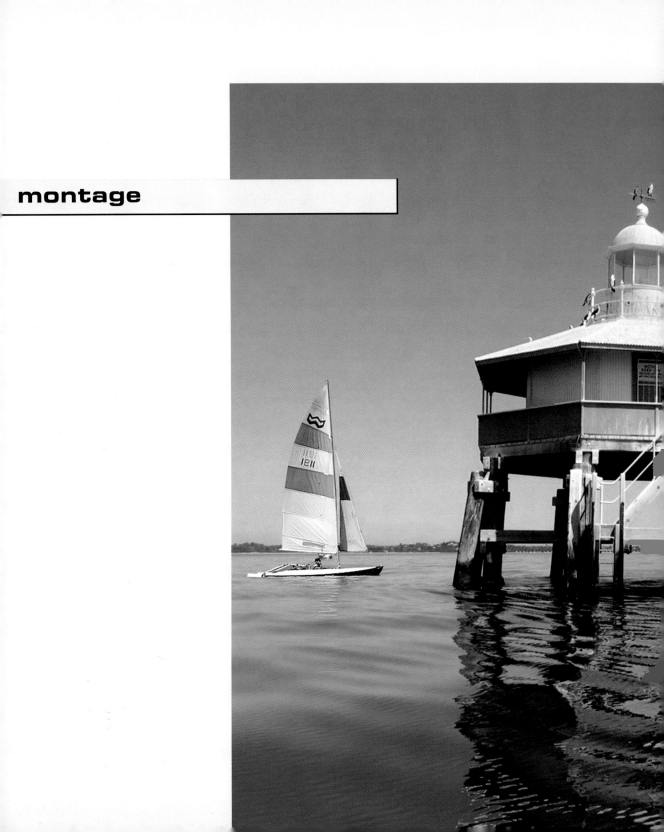

montage

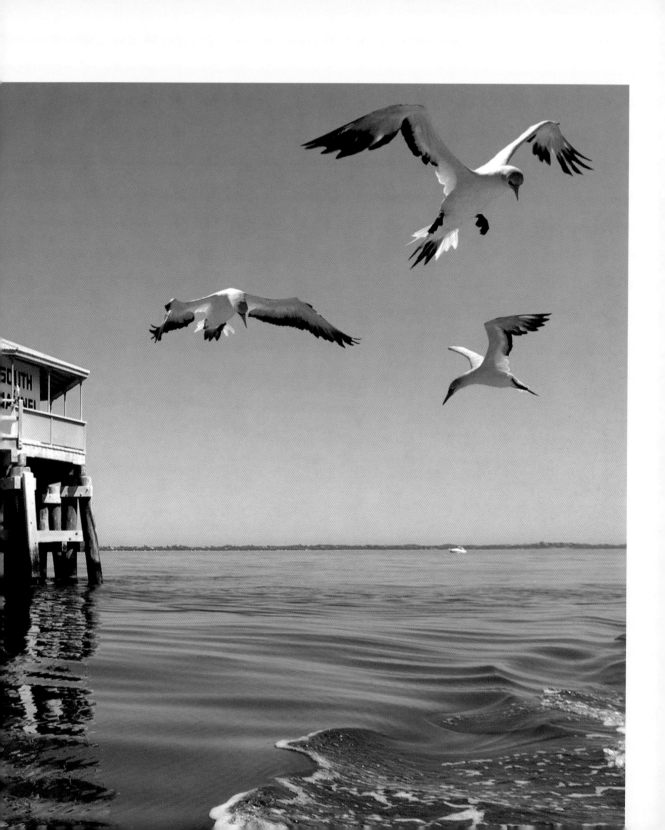

Ever since photography was invented photographers have experimented to create new images by combining others, or pieces of others. Today with digital technology the possibilities for new image making are greater and easier than ever.

1/ Luzette's assembled collection of images from libraries or found objects scanned directly on to a flatbed scanner.

2/ *Garden Delights.* Luzette scanned a piece of heavily textured paper, illustrations of a Victorian seed packet and flowers from an old gardening book.

3/ *Horse Power.* Another collection of found objects.

an introduction to montage

WILBOR'S COD LIVER OIL WITH PHOSPHATES

1

! Scanning 3D objects – With flatbed scanners you can produce excellent images of objects such as jewellery, leaves and other natural objects. Only those parts of the subject actually in contact with the glass will be in true focus so you can achieve an interesting depth-of-field effect if the object has significant depth. Place the object face down and mask off as much of the surrounding area as possible with black card to minimise flare. You may need to remove the lid of the scanner, in which case cover the object with a black lined box to avoid squashing it!

shoot

Photographer Luzette Donohue planned a series of images created from a collection of old photographs, textures and objects, all of which she either scanned on a flatbed scanner, or captured with a digital camera.

In *Garden Delights* (2), Luzette started with the background and scanned a piece of heavily textured paper, illustrations of a Victorian seed packet and flowers from an old gardening book. She combined these using the layers facility of Paint Shop Pro. Each image was laid down as a separate layer, and their opacity adjusted until she achieved the effect she wanted.

In the main image *Reminisce* (left), the women were photographed in Austria, whilst the brooch was scanned. The fish came from a royalty-free colour photograph, and the leaf shadows were derived from a scan of some leaves.

'This series of collages are comprised of individual photographs, textures, pictorial plates and objects, both natural and manmade. They are things I have been attracted to by their delicate beauty. I've chosen to arrange them in such a way that they suggest a narrative, and each one invites the viewer to ponder the story behind the curious collections.'

enhance

To start each image, Luzette created a <u>new canvas</u> in Paint Shop Pro with dimensions of <u>1760 x 2200 ppi</u> [2]. This created an <u>11Mb file size</u>, which she later printed at a size of 10 x 8in at a resolution of 220 ppi on an ink jet printer.

In the example *Stone Leaf*, the image of the leaf was opened, and the <u>magic wand</u> used to <u>select the background</u>. The selection was <u>inverted</u> to select the leaf which was <u>copied</u> [edit>copy]. The image of the stone was opened, and the leaf <u>pasted</u> on top as a new layer. Using the <u>layers properties dialog box</u> [3], the <u>opacity</u> of the leaf was reduced to 50% so that the texture of the stone showed through the leaf.

Luzette placed the stone and the leaf on to the glass plate of a flatbed scanner and scanned them as colour images. In the image shown the leaf was cut out from its background (by selecting the background with the <u>magic wand tool</u>, inverting the selection, then pasting it into the montage). The opacity was adjusted so that it blended in well with the rest of the image.

Image dimensions

Width: 1760
Pixels

Height: 2200

Resolution: 72.000 Pixels / inch

Image characteristics

Background colour: White

Image type: 16.7 Million Colours (24 Bit)

Memory Required: 14.7 MBytes

OK Cancel Help

share

Luzette's aim was to produce a series of four <u>10 x 8in</u> images which would be framed and displayed in a study. Each image was printed at a resolution of <u>220 ppi</u>, on to a <u>matt textured art paper</u> in an <u>ink jet printer</u>.

1/ Some of the objects and images that make up the image *Stone Leaf* opposite.

2/ To start each image, Luzette created a new canvas using the <u>new image dialog box</u>. Each image was given a dimension of 1760 x 2200 ppi. This created an 11Mb file size, for a 10 x 8in print.

3/ The opacity of each layer can be adjusted using the <u>layers control panel</u>. Here, the opacity of the leaf on layer 1 was reduced to 50% so that the texture of the stone showed through the leaf.

General | Blend Ranges

Layer

Name: Layer1

Blend mode: Normal

Opacity: 50

Group: 0

☑ Layer is visible

☐ Lock transparency

Mask

☑ Mask is enabled for this layer

☑ Mask is locked with layer

OK Cancel Help

! Working with layers –
If your program has a layers facility it is very handy for creating images such as these, in particular it allows you to treat each component as an image in its own right. The opacity, colour and the way it relates to the images underneath it can all be adjusted, as well as re-sizing it or moving it to another position.

'Even though I created the images, when I now look at them I feel as though I am peering into the private collections of sentimental things treasured by other people.'

1/ The monkey in the foreground is sharp, but the background is out of focus.

2/ The second image was refocused so that the background became sharp.

3/ Layers in Photoshop, showing the foreground image pasted on top of the background image.

4/ The layers palette showing the mask on the top layer, with a hole painted through by the airbrush.

montage techniques

Some of the uses of image montage are subtle, yet highly effective. A typical example is the photography of a wedding group, where one person might have their eyes shut at the moment of exposure. Most wedding photographers will shoot at least two images of the same scene, and use the eyes from one image to put into the other. Another example is the photography of animals, which are unpredictable in the extreme!

'Depth-of-field is always a problem with animals – you need fast shutter speeds to freeze movement. In this case I was hand-holding the camera, so I needed a fast shutter speed for a sharp image. The downside is that the background went out of focus due to the large aperture needed. I wanted to capture the full depth of the scene, so focused on the foreground for the first frame, then quickly focused on the background for the second. By the time I took the second shot the monkey in the foreground had moved.'

shoot

Wildlife photographer Steve Bloom travelled specifically to Japan to photograph the famous snow monkeys bathing in a hot spring.

Steve shot the images on 35mm film and then scanned them in a film scanner at a resolution of 3000 ppi, giving a file size of 30Mb.

enhance

Both images were opened in Photoshop [1/2]. The first image [1] with the foreground monkey in sharp focus, was selected [select all], copied, and pasted on top of the second image with the sharp background [2]. This automatically created a new layer [3]. I made a mask in this layer by clicking the new mask icon at the bottom of the layers palette and filled it with black [edit > fill > black]. This masked the effect of the top layer so that only the background image was visible. Then, using the airbrush tool, I brushed the foreground image into the scene by effectively painting a hole in the mask, and combining the two images together [4]. When it came to the detailed edges, such as the monkey's head, I zoomed in, and chose a smaller brush. I completed the image by enhancing the brightness and contrast.

share

The final image was placed in my stock photo library, and also printed at a resolution of 220 dpi on an A3 ink jet printer. A smaller version was re-sized and saved as a JPEG for my website.

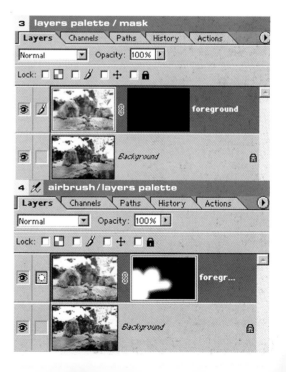

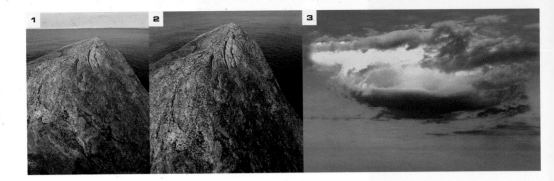

shoot

enhance

share

Since the early days of photography, photographers have improved their images by adding new elements to existing photographs. One of the most common examples of this is adding a new sky. Photographers would go out and actually shoot pictures of dramatic skies to be used at a later date.

Promontory by George Mallis is based on a rather small bayside rock formation in East Hampton, Long Island, New York.

Positioning myself only about 18 inches above ground level to give an unusual perspective and photographing with an ultra-wide 20mm lens on a 35mm SLR film camera to accentuate depth, the rock looms larger than life and the 'V' shape dramatically focuses our attention. However, the relatively clear sky lacks a central point of interest for the 'V' pattern to lead to [1]. The second image [3] provides the raw material for a focal point: a dramatic cloud formation, which was photographed on another day at the same location.

I cropped the image of the rock, removing the sky, and enhanced the tone and contrast using Photoshop's brightness and contrast controls [2]. Then I cropped the image of the cloud formation and made some minor changes to the density and contrast of that image.

To combine the new sky and foreground, I needed to add extra space at the top of the foreground image. I opened Photoshop's canvas size box [4] and increased the height of the image by 200%, placing the original at the bottom of the new canvas. Note that the file size has increased from 22Mb to 43.9Mb. I now selected the whole cloud image [select>all], copied it, then pasted it into the blank area on the new canvas [5]. Using the move tool I positioned it exactly above the foreground.

When I was happy with it, I flattened the two layers and ran the Photoshop blur tool along the edge of the sea/sky horizon to soften it very slightly. I cropped off the excess white space at the top, leaving a final file size of 36Mb.

I printed the image to A3 on an ink jet printer for an exhibition at an information centre. I made a second copy of the image at the lower resolution of 72 ppi for my website.

! **Layers** – When you paste an image on top of another, many programs, such as Photoshop, Elements or Paint Shop Pro automatically create a layer. This can be thought of as a sheet of glass containing an image that is on top of the original image. The glass can be moved around to enable the precise positioning of elements.

4 canvas size

Current Size: 22M
Width: 7.749 inches
Height: 7.098 inches

OK
Cancel

New Size: 43.9M

Width: 7.749 inches
Height: 200 percent

Anchor:

5 layers

Normal Opacity: 100%

Lock:

new sky

Background

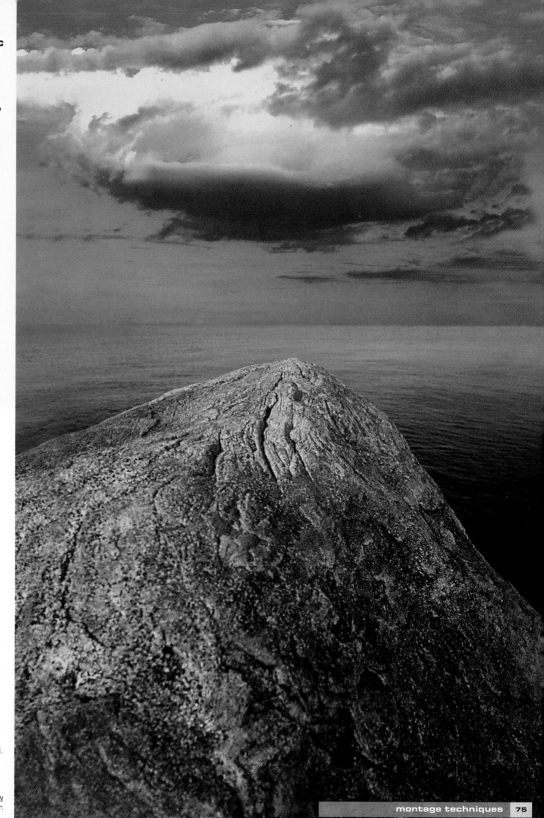

'The result is a much more dramatic image with leading lines directing us up to an interesting cloud formation. It is simplicity itself, but at the same time compelling.'

1/ The original image shot with a 20mm lens from a low viewpoint.

2/ The original image cropped.

3/ The new sky.

4/ Altering the <u>canvas size</u> to accommodate the new sky.

5/ Pasting the sky into the <u>new canvas</u> produces an extra layer.

creating effects

1/ The original sunflower image.

2/ The <u>custom settings</u> dialog box.

3/ A variety of effects created by different filters – the original image is shown top left and the version with the custom filter settings applied is shown bottom right.

digital filters

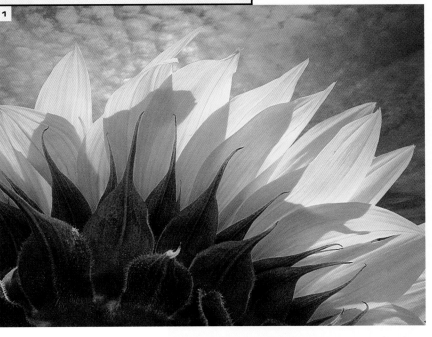

All software programs have a range of filters to enhance or modify images. Some add an effect over the top of the image, such as the noise or lens flare, whilst others distort the image, often beyond recognition. A range of them is shown here, applied to an image of a sunflower by Phil Preston.

One word of advice – don't overdo the effect of filters – try to apply an appropriate effect to an image. Too many exhibitions have examples of images with filters applied seemingly for the sake of it!

Filters can be applied in combination. For example, you might add 'noise' to a 'solarised' image. Take time to experiment.

The names of most filters are self-explanatory, but some such as the 'sumi-e' filter will need to be seen to see the effect. Many of the filters can be adjusted in terms of their strength or amount of distortion.

2 **custom settings**

		-1		
	-1	7	-1	
		-1		

Scale: 1 Offset:

OK
Cancel
Load...
Save...
☑ Preview

– 100% +

enhance

<u>Filters</u> can be thought of as mathematical equations applied to images. Some programs, such as Photoshop and Paint Shop Pro have the facility of allowing you to 'write' your <u>own filter</u> by <u>typing in numbers into a grid, or matrix</u>. The maths is hugely complex, but it is worth typing in some numbers to see what effects you can achieve. Often changing one number can make a great change to the effect. If you find one you like you can save it for future use.

3

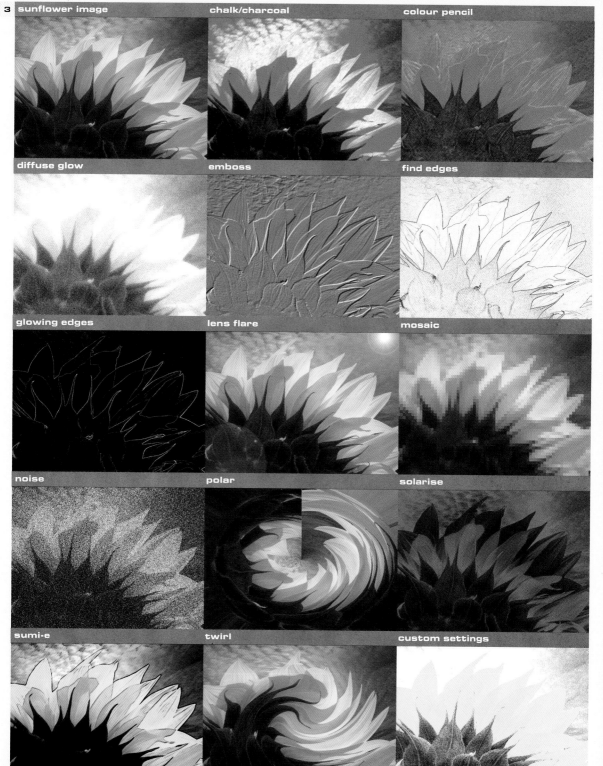

sunflower image

chalk/charcoal

colour pencil

diffuse glow

emboss

find edges

glowing edges

lens flare

mosaic

noise

polar

solarise

sumi-e

twirl

custom settings

traditional and digital techniques

shoot

enhance

share

This image by Rod Edwards was taken in the heart of poppyland in northeast Norfolk, in England. During the 19th century, this area was renowned for its poppies, and areas such as those around Cromer attracted artists and poets from far afield.

'As with all my images, I worked for a long time to achieve a strong, graphic composition that would hold together well when broken down into more abstract blocks of colour and shape. The discordant colours also seem to work well, providing a strong visual contrast, with red and blue being on opposite sides of the colour wheel.'

My initial thought was to shoot this scene with a telephoto lens to isolate the distant trees amongst the red poppies. However, after viewing segments of the scene with the lens I felt that a wider view would accentuate the foreground whilst still keeping the integrity of the image. In the end I used a 24mm lens on a 35mm single lens reflex film camera, together with a low viewpoint to get the effect I was after [1].

The final image is an example of image manipulation both at the taking stage and in the computer. I placed a skylight filter over the lens, smeared with Vaseline, and used the depth-of-field preview button to preview the effect with the smear filter.

I also used a graduated blue filter to increase the saturation of the sky.

After scanning at 2700 ppi, I adjusted the mid-tones and shadows with the levels and curves controls. Once I got the effect I was after I added yellow and red using the colour balance sliders [image > adjust > colour balance] to warm up the colours in the image and give the feeling of evening light.

Finally, I increased the granularity of the image using the grain filter [filter > texture > grain]. There are many types of grain found in this dialog box – regular, clumped or stippled, for example – all of which can be altered in their intensity [2].

This image has sold well through my website as a fine art print, printed on to an art surface ink jet printer. After re-sizing the image for the print dimensions I applied an unsharp mask to exaggerate the grain.

2 grain

OK
Cancel

− 100% +

Intensity 54

Contrast 39

Grain Type: Regular

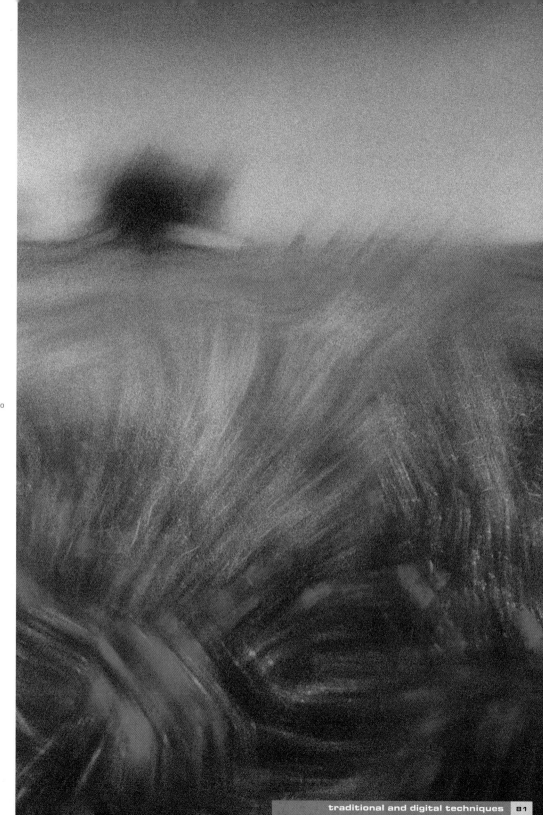

1/ The 'straight' image with no filter over the camera lens.

2/ Photoshop grain filter applied to the image.

I took the <u>shot</u> on <u>colour transparency film</u> looking towards the sun, which created a beautiful backlit effect on the blossom. I <u>scanned</u> it at a resolution of <u>2000 ppi</u> giving an <u>18Mb file</u> [1].

creative landscapes

enhance

There are occasions when it is impossible to imagine an effect before you apply it, and there is no short cut but to experiment with the image on screen. In this case a fine study of spring-time cherry trees has been manipulated by Walter Spaeth.

'I quite liked this spring-time shot of cherry trees, but felt that digital image processing might produce another version of the image giving a completely different feeling.'

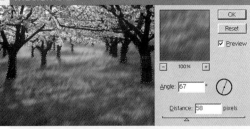

I used the <u>channel mixer</u> [image > adjust > channel mixer] in Adobe Photoshop to produce an interesting variation to the colour of the image. This interesting facility, found for example in Photoshop and Paint Shop Pro allows you to change the colours of individual channels and mix them together. In this example, the red and green channels have had their values altered to produce a sepia effect [2].

After getting the colour I liked I used the <u>lasso tool</u> to make a <u>selection</u> around the tree trunks and ground around them. I then used the <u>motion blur filter</u> to blur the grass around the trees [3].

Finally, when I had achieved the effect I was after I darkened the whole image a little using the <u>brightness and contrast control</u> to give it a more sombre feel [4].

share

I needed a high-quality print for framing so I <u>printed</u> the image to <u>A3</u> on to a <u>textured ink jet paper</u>. I also produced a <u>lower resolution version</u> of the image for my <u>website</u>.

1/ The original image of cherry trees in spring time.

2/ Photoshop's <u>channel mixer</u> allows you to mix and blend colours to produce interesting results.

3/ Photoshop's <u>motion blur filter</u> was used to introduce an element of movement into the image.

4/ The final effect was enhanced by modifying the <u>brightness and contrast</u> of the image.

! <u>**Channel mixer**</u> **– Try this feature with different types of images. It is very hard to predict the results!**

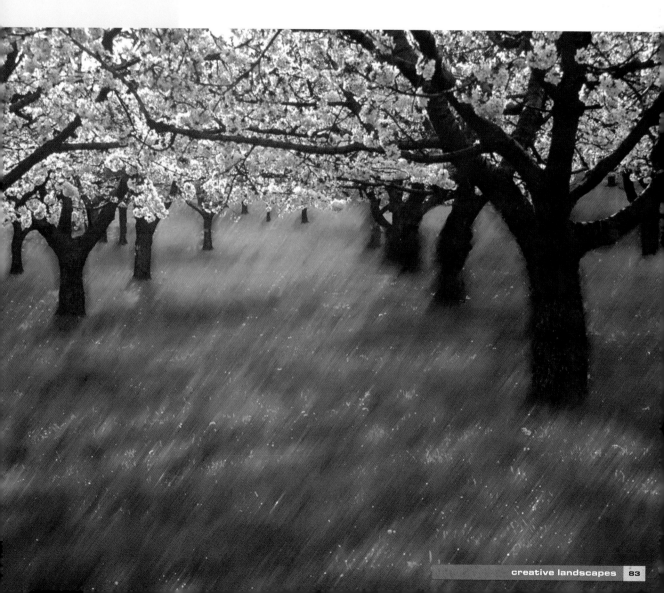

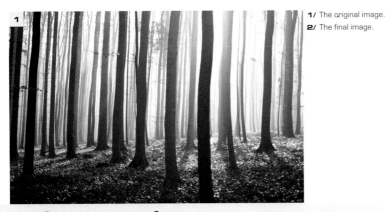

using masks

Another example of atmosphere enhanced by image processing is this woodland image, *Greenfog*, by Walter Spaeth. The original shot had lovely aerial perspective due to the combination of backlighting and mist, but lacked a major focal point of interest.

shoot

I shot this woodland scene very early one morning on 35mm transparency film, using a 28mm wide-angle lens. I scanned the image in a film scanner at a resolution of 2000 ppi to give a file size of 18Mb, with the intention of producing an A3 print.

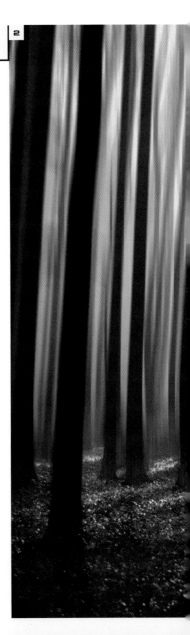

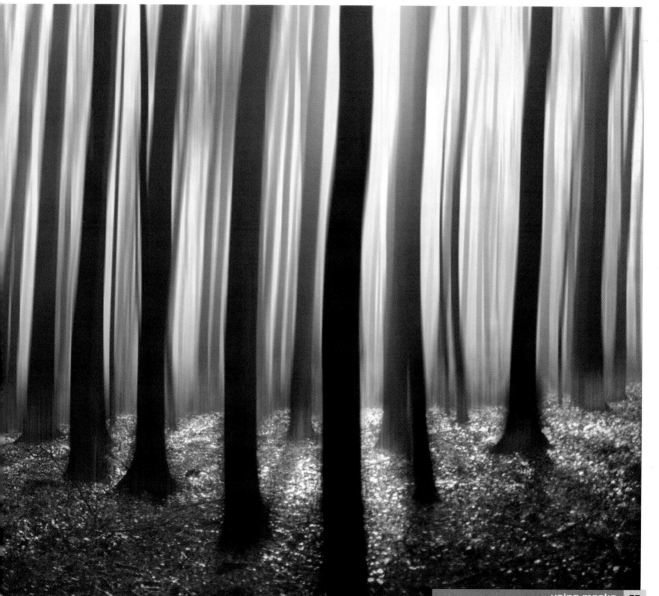

3/ The foreground selected with the lasso tool.

4/ The colour of the foreground was given a warmer tone by adding red using the variations dialog box.

5/ The image in quick mask mode. You can now paint in areas to be selected with a paintbrush. Access to the quick mask mode is at the bottom of the toolbox.

6/ The motion blur filter applied to the trees in the background.

7/ The colour of the background was changed to green using the hue/saturation control.

8/ The brightness and contrast controls were used to make final adjustments to the overall tonal balance of the image.

> **!** **Quick mask** – This feature puts a red mask over selected areas. The mask can be added to, or subtracted from by painting with a paintbrush. When finished, the mask can be turned off to reveal a new selection area.

enhance

My first step in the manipulation process was to <u>select</u> the ground beneath the trees using the <u>lasso tool</u> [3]. Using the <u>variations</u> dialog box in Photoshop, the selected area was given a warmer tone by adding red to it [4].

Next, the selection was <u>inverted</u> and the <u>quick mask option</u> selected.

Individual tree trunks could now be painted with a <u>paintbrush</u> to remove them from the selected area [5].

Coming back out of quick mask mode, the <u>motion blur filter</u> [filter > blur > motion blur] was applied to the area behind the trees to create a misty, ethereal effect [6]. I experimented with the settings until I got the one I liked.

Retaining the selection, the colour of the background was changed to a green colour with the <u>hue/saturation</u> control [7].

Finally I darkened the whole image and increased the contrast using the <u>brightness and contrast</u> controls [8].

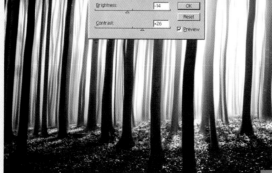

share

The image was intended to be printed as part of a series on atmospheric woodlands. I printed it to <u>A3</u> size on an <u>ink jet printer</u> from the final high resolution <u>TIFF</u> file. I made a second, lower resolution <u>JPEG</u> version for my website.

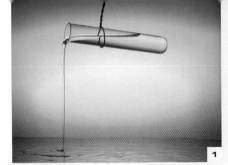

This image was for a camera club exhibition and was <u>printed</u> on an <u>ink jet</u> printer. The image needed to be <u>12 x 10 in</u> which gave a file size of approximately <u>14Mb</u>, at a resolution of <u>200 dpi</u>.

retouching for special effects

shoot

enhance

The aim of a lot of special effects photography – both in still and moving imagery – is to create an optical illusion. With digital imaging it has become much easier to produce images which confuse the eye, and place objects in impossible situations.

Ray Grover found this image fairly straightforward to shoot. The test tube was suspended above a bowl of water and a multicoloured background was projected behind it. Ray took several <u>shots</u> to make sure there was a good ripple effect in the water. He used a <u>3 megapixel digital camera</u> set to its finest setting for high quality. External electronic flash heads were used to illuminate the subject [1].

The success of this image lies in deceiving the eye into thinking the test tube is suspended in mid air. To achieve this effect Ray had to retouch out the wire holding the tube.

Ray used the <u>cloning</u>, or <u>rubber stamp tool</u> in Paint Shop Pro, and carefully replaced the wire with the corresponding background colour and pattern. He chose a soft-edged brush, slightly larger than the width of the wire [2]. The tool was placed adjacent to the wire, and the right hand mouse button <u>clicked to select the source area</u>. Ray moved the tool over the wire and <u>clicked</u> the left-hand button <u>to paint over</u> the wire with the colours and patterns of the source area. A cross appears to indicate the source area.

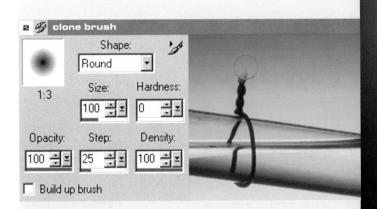

2 clone brush

Shape:
Round

1:3

Size: 100 Hardness: 0

Opacity: 100 Step: 25 Density: 100

☐ Build up brush

1/ The original image showing the test tube suspended by the wire.

2/ Ray chose a soft-edged brush slightly larger than the width of the wire from the <u>clone brush dialog box</u>. He used the <u>clone brush or rubber stamp tool</u> to paint over the wire with the colours and patterns selected from the source area.

! **Zoom in with the zoom tool to help you clone fine areas of detail [2].**

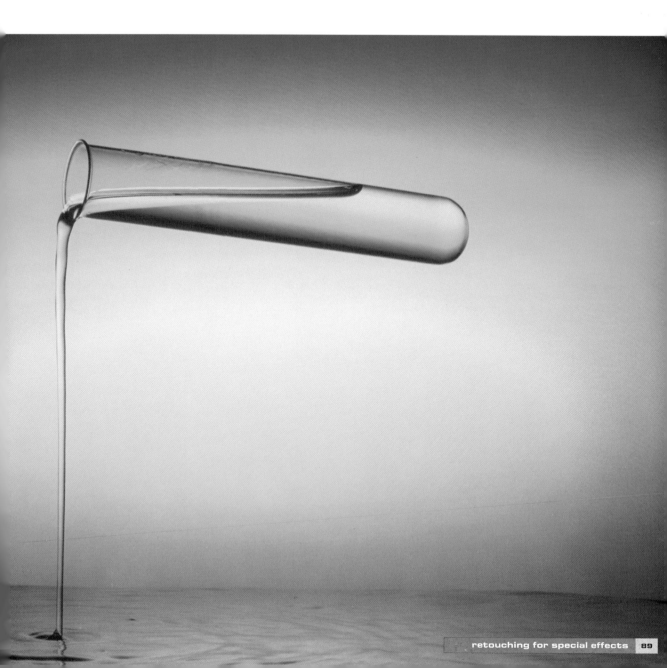

shoot

The original <u>shot</u> by Daniel Lai was taken on <u>35mm transparency film</u> which was <u>scanned</u> at <u>2700 ppi</u>, with the aim of producing an <u>A3 print</u>[1].

share

I <u>printed</u> the image to A3 on an ink jet printer using an <u>ink jet art paper</u>, and made a second, <u>lower resolution</u> version at <u>72 ppi</u> for my <u>website</u>.

creating painterly effects

enhance

'Over-sharp photos can sometimes bore and frustrate me. I have always felt that perhaps I could break the mould. A year after a trip to Italy, I saw an advert in a photography magazine. It was about a new lens that could produce part sharp, part-blurred images. One of the examples was a picture of Venice, which had a softness that made it look very "painterly". I fell in love with the effect and dug out this old picture taken in Venice. I cut out the photo from the magazine, pasted it on to my monitor and started to manipulate my image hoping to emulate the painterly softness.'

! | Channels – Most colour images are composed of three channels: red, green and blue. As you can see in this example, you can make changes to each channel to create interesting effects. As Daniel Lai says in his commentary, you will need to experiment to see how to achieve the exact effect you are after.

2 | hue/saturation

Edit: Blues
Hue: 0
Saturation: 448
Lightness: 0
195°/225° .255°\285°
OK
Cancel
Load...
Save...
☐ Colorize
☑ Preview

I started by changing the overall <u>colour balance</u> of the image, increasing the saturation of the blue colours of the gondolas using the <u>hue/saturation control</u> [edit > image > hue/saturation] [2], then adjusting the overall colour balance and tonality of the image until I was happy.

Next, I opened the <u>channels palette</u> in Photoshop [window > show channels] and clicked on the green channel [3]. I applied a <u>gaussian blur filter</u> [filter > blur > gaussian blur] to this – blurring just the green colours [4]. I also applied a <u>diffuse glow</u> to this channel [filter > distort > diffuse glow] [5].

Then, I selected the blue channel, and applied a <u>motion blur</u> to this [filter > blur > motion blur] [6]. I made some changes to the <u>tonal and colour balance</u> to finish it.

3 | channel mixer

RGB Ctrl+~
Red Ctrl+1
Green Ctrl+2
Blue Ctrl+3

4 | gaussian blur

OK
Cancel
☑ Preview
– 100% +
Radius: 10 pixels

5 | diffuse glow

OK
Cancel
– 100% +
Graininess 6
Glow Amount 3
Clear Amount 10

6 | motion blur

OK
Cancel
☑ Preview
– 100% +
Angle: 61 °
Distance: 166 pixels

1/ The original photograph of Venice.

2/ Changing the overall colour balance of the image by increasing the saturation of the blue colours of the gondolas using the hue/saturation control.

3/ The channels palette in Photoshop showing the green channel selected.

4/ The gaussian blur filter applied to just the green channel. You can make changes to each channel or create a new channel to create interesting effects.

5/ The diffuse glow filter also applied to the green channel.

6/ A motion blur filter applied to the blue channel.

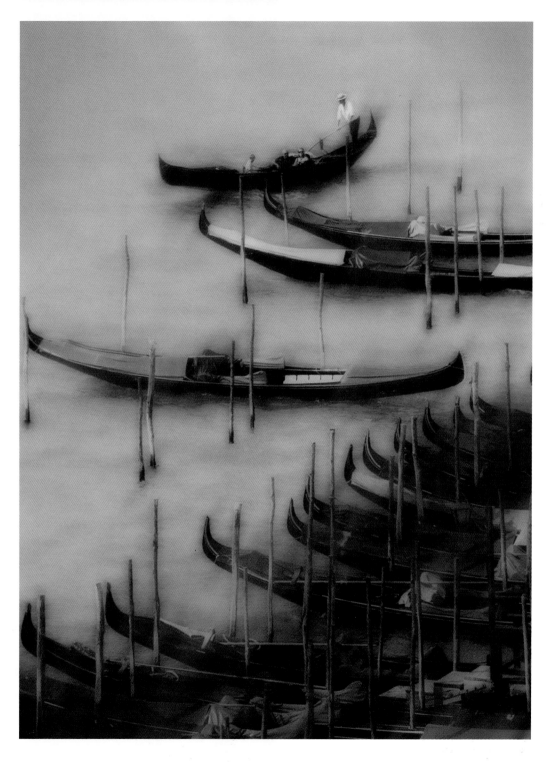

'The weather was crisp and glorious when we arrived, so I planned to get up at the crack of dawn the next day for some tasty sunrise images. However, when I staggered out of bed at a ridiculous time the following morning, this plan had to be abandoned immediately. To my horror, the sky was a leaden grey and it was starting to sleet. Not too promising...'

solarisation

shoot

One of the uses of digital image processing is to inject new life into otherwise dull and uninteresting images. Most programs have a huge range of filter effects, as well as controls for adjusting colour brightness and contrast, and, used in combination, these can give interesting results.

The skill is to use the effects sparingly and choose the right image, so that the effects enhance the image rather than become the image itself.

This image by Jon Bower was shot during the dark mid-winter months of 2001.

My wife and I happened to be staying in London at the time, at a hotel just next to the London Eye. Although photography was not high on our agenda, I had my gear with me, as always, just in case.

At the back of my mind was the idea of shooting something completely different from the rather prosaic commercial images I had seen previously of the Eye.

The weather was crisp and glorious when we arrived, so I planned to get up at the crack of dawn the next day for some tasty

sunrise images. However, when I staggered out of bed at a ridiculous time the following morning, to my horror, the sky was a leaden grey and it was starting to sleet. Not too promising... but I was determined to capture something.

One advantage of the timing and weather was the lack of crowds. No one but a daft photographer or street walker would be around at such a ridiculous time! I knew that the Eye still presented a strong form in this light, but that something else was needed to make the composition. I was sure that a lone figure, his image reflected in the slick, wet

pavement, was what was needed. Naturally, no one obliged until, after an hour or so, this early morning masochist appeared. I shot several images in quick succession, then staggered back for a much-delayed hot breakfast.

Back at the studio my next step was to scan the film at 4000 ppi in a 35mm film scanner [1].

! Solarisation is an old photographic technique for partially fogging photographic materials during processing. Part of the image becomes a negative, whilst the other remains a positive.
A similar effect can be achieved using the curves control in Photoshop [3] and other programs.
Try experimenting with the shape of the curve to produce interesting effects!

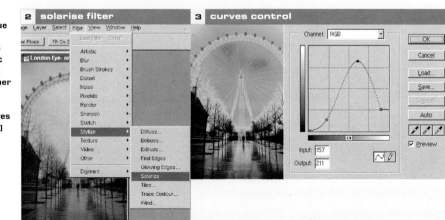

2 solarise filter **3 curves control**

1/ The original image shot on film was taken on a wet day and produced a dull picture with a bland sky.

2/ The solarise filter in Adobe Photoshop is found in the stylise set of filters.

3/ Curves control adjusted in Photoshop to produce a solarised effect.

enhance

I tried various enhancements in Adobe Photoshop, including inverting the tones so that the image became a negative and adjusting the various hue/saturation settings. What seemed to work well in the end was to 'solarise' the image [filter > stylise > solarise] [2]. Although it cannot be adjusted, this filter produced the sort of effect I was after. After applying the filter I then adjusted the brightness and contrast settings until I achieved a dark sky and bright foreground.

share

I sent the image to my picture library as a 72Mb digital file. Most picture libraries ask that files are at least 48Mb to cover all reproduction sizes. So scan at as large a size as possible in case the image needs to be cropped. I didn't sharpen it as images are often sharpened before printing in magazines and books.

shoot

I <u>shot</u> this image of the Vancouver skyline from a cruise ship. As expected, it turned out to be a mediocre snapshot, however, I wanted to create an image of the Vancouver skyline viewed from the sea on a very stormy day [1].

! When making an image with a number of effects filters and other changes it is worthwhile saving the various changes as different files – 'storm – blur **1**', 'storm – diffuse' etc. You can then compare them before deciding which one you like best. You can always delete the unwanted ones at the end of the whole process.

creating atmospheres

Sometimes an effect imagined by a photographer will take a lot of experimentation and involve a large number of different techniques and filters. This image, by Daniel Lai, is a simple, rather mundane view of the Vancouver skyline, turned into an evocative image of a storm.

'This image would have been impossible with conventional photography. Moving clouds would have needed a tripod and a long exposure – out of the question in this case. The major success of this image for me is that the elements that were present at the actual time of taking the shot are recreated; the moving clouds blown by the wind and the diffuse sunlight. The blurred edges around the top of the buildings – a result of selected pixels being smudged by the motion blur filter – give the image a softness that is often perceived during a storm. Light diffusion and the graininess that comes with it further enhance this softness.'

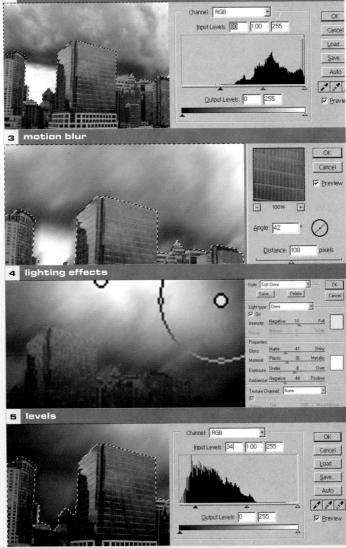

1/ The original image.

2/ The tones of the sky have been adjusted using the <u>levels</u> command.

3/ Keeping the sky selected a <u>motion blur filter</u> was applied.

4/ In the <u>lighting effects filter</u> the Omni light with a yellow colour was chosen.

5/ With the selection inverted so that the lower half of the image was selected, the tonal balance was adjusted using the <u>levels control</u>.

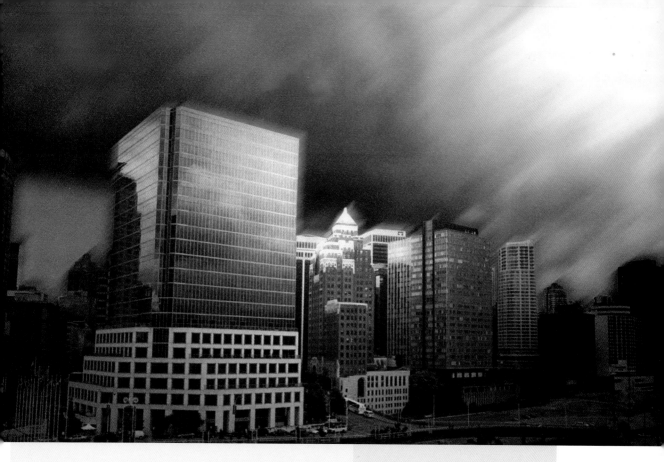

enhance

Using Adobe Photoshop my first step was to <u>select</u> the sky area with the <u>magic wand tool</u> (I could have used the <u>polygon lasso tool</u>). I adjusted the tones of the sky using the <u>levels</u> command [2]. I dragged the left-hand slider along to darken the sky and give it more contrast. Keeping the sky selected I applied a <u>motion blur filter</u> [3]. Next I applied a <u>lighting effects filter</u> [filter > render > lighting effects], choosing, after trying various options, Omni light with a yellow colour [4].

I <u>inverted the selection</u> so that the lower half of the image was selected, and adjusted the <u>tonal balance</u> with the <u>levels control</u> [5]. I increased the contrast with the <u>brightness and contrast control</u>.

Finally, I applied the <u>diffuse glow filter</u> [filter > distort > diffuse glow] [6], giving the image a 'radiant effect'. I found that I

needed to increase the contrast again in order to compensate for the loss caused by the diffusion filter.

6	diffuse glow

	OK
	Cancel

− 100% +

Graininess	6
Glow Amount	12
Clear Amount	20

share

I made an <u>A3</u> print of the image on an <u>ink jet printer</u>, printed on to an art surface paper, and framed it in a contemporary metal frame. I then made a second copy at a <u>resolution</u> of <u>72 ppi</u> for my <u>website</u>.

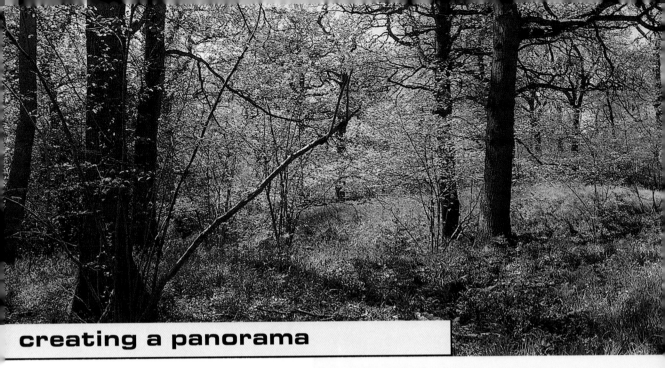

creating a panorama

shoot

The traditional way of producing a panoramic image is to take a series of photographs and stick them together on a mount, butting their edges together. This invariably produced a crude result. Digital imaging has made this task much easier, and can produce seamless results, with dedicated software such as the 'stitch' facility in the platinum version of MGI PhotoSuite 4, or the 'photomerge' facility of Adobe Elements. The basic idea is to produce a series of overlapping images, which can be seamlessly stitched together.

I had planned this image for a couple of years, waiting for the right time and place! I looked carefully for the right location within the bluebell wood, so that all parts of the image had interest. One view was rejected because the ground sloped away and I could not see it through the camera lens. I <u>shot</u> it on a <u>digital camera</u> using the <u>wide angle end</u> of the <u>zoom range</u>.

Use a <u>tripod</u> to keep the camera perfectly horizontal. Some tripod heads are calibrated in degrees to make it easy to line up the camera – or use a spirit level.

Most software works best when there is an approximate <u>30% overlap</u> in the images. So if you intend to shoot a full 360 degree panorama you will need from 12–18 images depending on the focal length of lens used.

1/ The <u>photomerge</u> facility within Adobe Elements. I loaded the <u>source files</u> in the right order and <u>asked</u> the software to merge the images.

2/ The <u>photomerge dialog box</u>, showing two overlapping images, and the ability to navigate across the panorama.

3/ The software looks for common features within images and overlaps them.

4/ The two images merged.

1 source files

Choose two or more files to create a panorama composition, or click the Open button to view an existing composition.

Source Files

```
1.1.jpg
2.1.jpg
3.1.jpg
4.1.jpg
5.1.jpg
6.1.jpg
7.1.jpg
8.1.jpg
```

Add...
Remove
Open
Help

Settings
☑ Attempt to Automatically Arrange Source Images
☑ Apply Perspective
Image size reduction: 50%

Cancel OK

2 automatic alignment

OK
Cancel
Save As...
Help
Tutorial

Navigator
100%

Tool Settings
Dragging: Ghost
☑ Snap to Image
☐ Use Perspective

Composition Settings
☐ Cylindrical Mapping
☐ Advanced Blending

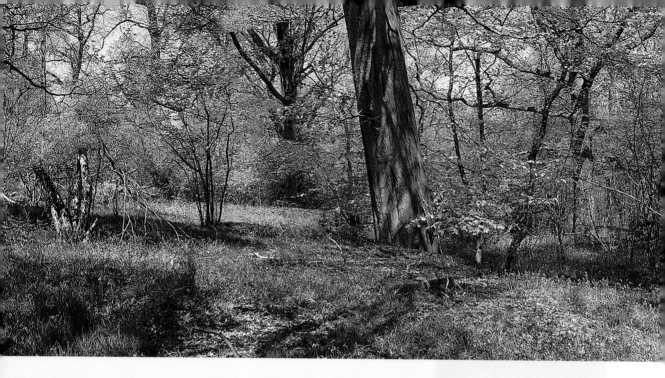

enhance

The <u>photomerge</u> facility within Adobe Elements recommends that the images are no larger than 2Mb in size. As I had shot them on a 3-million pixel camera I had to re-size them in the <u>image size box</u>. I <u>loaded</u> them into the software in the right order [1], and <u>clicked</u> OK. The software loads the images and attempts to <u>merge</u> them <u>automatically</u> by looking for common features to line up [2]. If it cannot do this a dialog box will alert you. You can then <u>align</u> the images <u>manually</u>, by <u>dragging</u> them over the top of each other. I found this very easy. A 'ghost' area appears allowing you to line up features [3]. The small discrepancy often left at the top and bottom of the final image can be <u>cropped</u>. Finally I adjusted the <u>brightness, contrast and colour balance</u>. As the original images were saved as JPEGs it was important not to compress them again, so I saved the final image as a <u>TIFF</u> file.

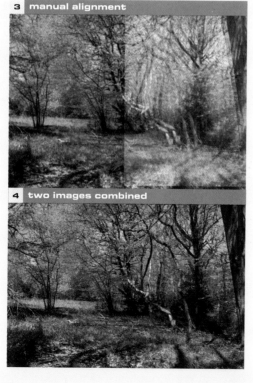

3 manual alignment

4 two images combined

share

Panoramas can be <u>printed</u>, or <u>viewed</u> on computer monitors where they can be made to be interactive – i.e. you can pan around them.

For printing, special <u>panoramic format paper</u> (148.5 x 420mm) is available, though you can cut down A3 or A2 if required. The final 360 degree image measured 46 x 400mm and was printed at a resolution of 240 ppi on an ink jet printer.

Some ink jet printers also have a <u>roll paper</u> facility, so you could make even larger panoramas on rolls of paper.

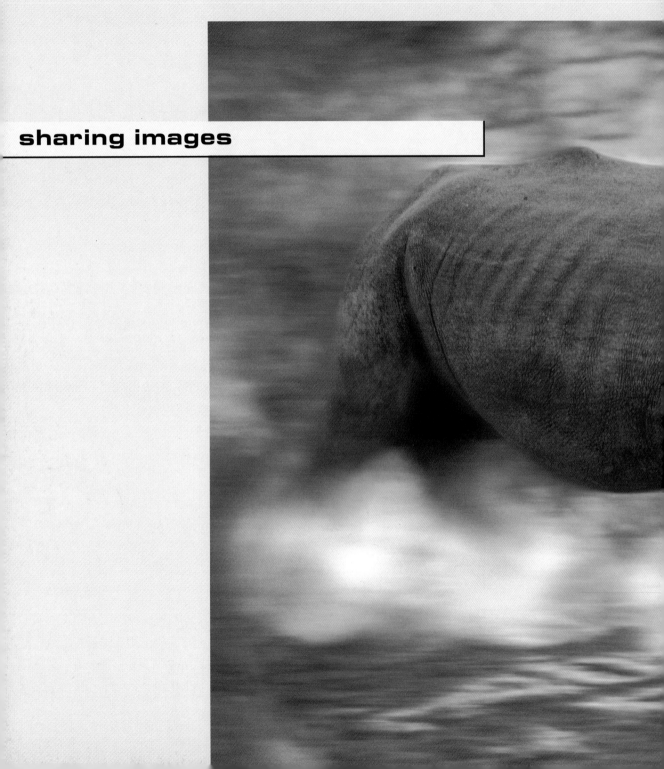

sharing images

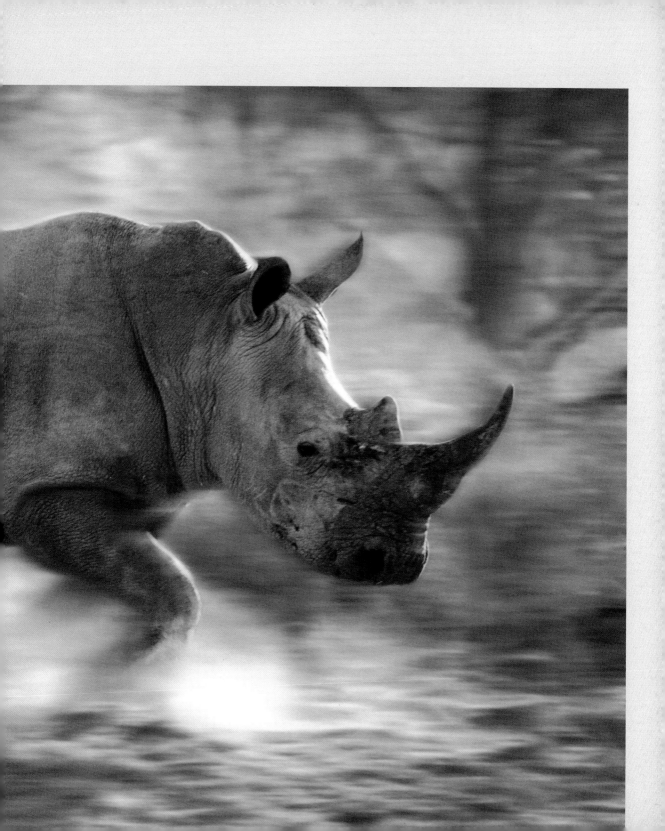

printing your image

There are many different types of computer printer – thermal dye sublimation, thermal wax, laser and ink jet, but for most home users it is the ink jet which has become best known. Over the last few years they have become inexpensive and can produce prints indistinguishable from conventional photographs. They can print on to a wide range of paper surfaces and weights, including canvas and art paper.

Ink jet printers have four colours of ink: cyan, magenta, yellow and black. Minute droplets of each colour are sprayed on to the paper surface at high speed [3].

'Photo' type printers often have six inks: cyan, magenta, yellow and black, plus light magenta and light cyan. The two extra colours help smooth out subtle tones such as skin colours.

Print quality is determined by the image resolution, the printer resolution and the type of paper. Most printers are quoted as having resolutions of 720 or 1440 dpi. Digital images are composed of pixels, and in order to print each pixel to the right colour and density, the printer must put down a number of dots of ink for each pixel. These dots may vary in size, but when viewed at a distance these merge together to give a continuous tone image [3]. The effective printing resolution of most ink jets is in the region of 200–240 pixels per inch (ppi). This will vary according to the type of paper media used and it is worth doing some tests with your own equipment.

1 ink

2 light

3 pixels vs. droplet

1/ Ink: Cyan, Magenta, Yellow = Black + Red, Green and Blue.

2/ Light: Red, Green, Blue = White, + Yellow, Magenta, Cyan

3/ An inkjet printer puts down a number of dots for each pixel.

4/ Image size dialog box showing image at 72 ppi (resolution of monitor).

5/ Image size dialog box showing image at 220 ppi (resolution of printer).

6/ Image re-sampled to give larger print size at 220 ppi.

7/ Print size vs. file size – the table gives some examples of pixel dimensions, approximate print size and file size for different print sizes, when printed on an ink jet printer at 200 dpi.

! **Bicubic re-sample** – by re-sizing the image using bicubic re-sample, relatively small images from compact type digital cameras can be printed at quite large sizes.

getting the image ready

To show the techniques of sizing images we have used Adobe Photoshop. Most other programs, such as Paint Shop Pro and Adobe Elements, will have similar features. The screen shot [4] shows the image size dialog box. This will show the size of image on screen and how large it will print at a certain resolution. Usually, when first opened, the resolution displayed will be 72 ppi (the resolution of most monitors). The screen also shows the image size – 11Mb, and pixel dimensions – 2547 x 1500. The print dimensions at this low resolution are a massive 89.85 x 52.92cm, but as we have already discussed, the printer is capable of printing at a much higher resolution than that.

The first task is to adjust the resolution to match that of your printer. In the example shown here [5], I did not check the re-sample box, and typed in 220 ppi (the resolution at which the printer will print the image). Notice that as the resolution is increased, the print size decreases, in this case from 89.85 x 52.92cm, to 29.41 x 17.32 cm. Note that the image has remained the same size in terms of number of pixels – they are compacted into a smaller space to increase the resolution.

If you need a larger print size, then another option is to increase the number of pixels in the image (you can also decrease the number for smaller prints). This is known as re-sampling. To do this,

click the re-sample box [6]. In the example shown, I doubled the width of the printed image from 29.41 to 58.82cm. Note that the number of pixels has increased from 2547 x 1500 to 5095 x 3000. The option bicubic re-sample has been selected – this will give the best quality. The software invents, or interpolates the new pixels by using highly complex maths. Note too that the file size has quadrupled, from 11Mb to 43.8Mb! (The size of the image has been doubled in both directions, height and width, giving four times the number of pixels). In this way, relatively small images perhaps from compact type digital cameras can be printed at quite large sizes.

4 | **image size**

Pixel Dimensions: 11M
Width: 2547 pixels
Height: 1500 pixels

Document Size:
Width: 89.85 cm
Height: 52.92 cm
Resolution: 72 pixels/inch

Constrain Proportions
Resample Image: Bicubic

5 | **image size**

Pixel Dimensions: 11M
Width: 2547 pixels
Height: 1500 pixels

Document Size:
Width: 29.41 cm
Height: 17.32 cm
Resolution: 220 pixels/inch

Constrain Proportions
Resample Image: Bicubic

6 | **image re-sampled**

Pixel Dimensions: 43.8M (was 11M)
Width: 5095 pixels
Height: 3000 pixels

Document Size:
Width: 58.82 cm
Height: 34.64 cm
Resolution: 220 pixels/inch

Constrain Proportions
Resample Image: Bicubic

7 | **print size vs. file size**

pixel dimensions	800 x 1200	1600 x 2000	2400 x 3000
print size cm	15 x 10	25 x 20	37.5 x 30
file size Mb	2.75	9.16	20.16

setting up the printer

> **!** **Ink jet paper types –** There is now a large range of paper surfaces and weights available for ink jet printers, ranging from 'traditional' glossy and matt surfaces to canvas and various art papers. Again, it is worth experimenting with different types to see which suits your images best. You can even try 'non ink jet' art papers. The ink may bleed into the fibres, but you might like the result!

> **!** **Archival permanence –** An area of concern with ink jet printers is that of print longevity – how long will the prints survive before they have faded? The issue is complex, and is a factor of the relationship between the inks used in the printer, and the acid content of the paper. Recently several manufacturers, notably Lyson, have started to produce archival inks and archival papers, which have a life of around 60–80 years.

Open the printer dialog box and select the advanced settings [custom>advanced] [1]. This will allow you to access controls for the paper type, resolution and the like.

It is very important to select the right paper type, as this setting determines how much ink is put on to the surface. The printer will put less ink on to a high gloss finish than a plain paper. In this case heavyweight matte was selected [2]. Now select the printing resolution – 720 or 1440 dpi (it is worth doing some tests here, you may not notice any difference between 720 and 1440!). Note that high speed has been turned off. This feature *may* reduce quality.

The quality option (sometimes called 'half-toning') is very important – select high quality (or error diffusion on some older machines). This places the ink dots in a random pattern rather than in straight lines, mimicking the effect of film grain. Experiment again with the finest detail setting. You may find it makes little difference, or you may prefer images without it.

1 printer settings

2 custom settings/advanced

1/ Printer controls showing custom settings with advanced mode selected.

2/ Advanced printer settings, showing paper type, resolution and quality.

3/ Canvas size dialog box in Photoshop showing increase in canvas to produce test matrix.

4/ Test matrix – A composite image of the original and copies with adjusted colour values. Print on to a sheet of paper and assess the result.

5/ Test strip – Select a part of an image, and give it different brightness, colour or other values. This mimics the darkroom technique of producing test strips. Watch you don't miss out an important area of the image.

getting the right density and colour

Getting the print to match the monitor display can be a very difficult and complex process, involving colour management techniques beyond the scope of this book. However, it is possible to produce tests, rather like the test strips made by photographers in the darkroom.

The simplest method is to select an area of an image, apply a setting to it, then select another area and apply another setting. You can give the same image various settings for brightness, for example [5].

A better method is to make a composite. Open an image and increase the canvas size [image> canvas size] by just over three times the size of the cropped image [3]. Select the image with the rectangular selection tool, copy, and paste it back into the new canvas. Use the move tool to put the pasted image into the top left-hand corner. Now repeat this five more times to produce a window with a central image and six others surrounding it. Now you can select each individual image with the rectangular selection tool, and adjust the colour balance [4]. Print this sheet, and compare it to the monitor display. This will give you a good indication of how close your monitor is to your printer. When you decide which image you prefer, apply the settings to the whole image and print it. You can do similar sheets for density and contrast as well. Once you have done a couple of these tests, you will start to be

able to predict how your printer will print your images, and you may be able to dispense with these tests altogether.

When viewing the result it may be worth making a mask from black card which only shows one image at a time. Hold this over the print so that you can examine each image without it being affected by the others in the sheet.

3 **canvas size**

Current Size: 2.06M
Width: 3.12 inches
Height: 2.56 inches

[OK]
[Cancel]

New Size: 18.6M
Width: 300 percent
Height: 300 percent
Anchor:

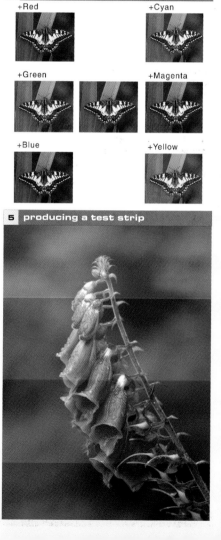

4 **making a test matrix**

+Red +Cyan

+Green +Magenta

+Blue +Yellow

5 **producing a test strip**

using text

There are many reasons for adding text to images – to create greetings cards or calendars, posters, or perhaps teaching materials. Most imaging programs have the facility to generate text. The text will become a part of the bitmapped image, i.e. composed of square pixels, and may show a jagged edge rather than a clean smooth edge. This is known as *aliasing*, but shouldn't be too much of a problem if it is not enlarged too much.

As well as changing the size, font (style) and colour of the text, many programs offer the ability to distort the shape, add shadow effects, and fill the lettering with a pattern. A selection is shown here. The basic technique is to select the letters with the magic wand tool and then apply the effect to the text.

1/ The black text colour has been changed by filling it with a blue colour using the <u>bucket tool</u>.

2/ The text shape can also be filled with another image. In Elements I opened an image of a leaf I had scanned (see page 21) and selected a rectangular area of the image with the rectangular marquee tool. I copied this and used the command <u>paste into</u>, which places the leaf into the selected area of the text.

3/ The text shape can also be distorted, or <u>warped</u>. Here, the <u>arc option</u> was chosen from the <u>distort dialog box</u> and a fairly gentle distortion applied. Beware; if the text is distorted too much it can become almost unreadable!

| 1 colour fill | 2 image fill |

3 **distort text**

6/ This was one of a series of images for a calendar. I applied the word *January* to the image of a winter woodland. In this case I have selected a colour from within the main image using the <u>dropper tool</u> and used this for the colour of the text.

4 | gradient fill

4/ The text can also be coloured with a gradient. Here I selected a <u>spectrum gradient</u> from the <u>gradient editor</u> in Photoshop Elements.

5 | drop shadow

5/ A <u>drop shadow</u> gives the lettering a three-dimensional appearance. In Photoshop Elements there are two options – a <u>high</u> and <u>low</u> shadow. In other programs there may be a greater range of options.

The second example shows the drop shadow effect used in conjunction with the <u>filled</u> text.

images and the net

The tremendous growth in the **World Wide Web** has given photographers a new medium in which to display, market and distribute their work. We view web pages on computer monitors, which have a relatively low resolution compared to digital printers. As web pages are usually transmitted by phone line, you should keep the size of the files as small as possible to reduce <u>download</u> times.

1/ The <u>web photo gallery</u> option in Photoshop 6. Options include the overall <u>design</u> of the page and the amount of <u>JPEG compression</u> which will influence image quality.

2/ The finished page shown in the <u>web browser</u> Microsoft Internet Explorer. Clicking on an image in the left-hand frame automatically links to a higher resolution version, which will appear in the main area of the page.

shoot

I wanted to produce a mini portfolio of some of my plant photographs taken with digital cameras, and display them on a website. I chose six images initially, with the aim of adding more at a later date. The six were to be viewed all together like a contact sheet. Clicking on each one would link to a larger version of the image on screen. I shot the original images on a 2.4 megapixel SLR type digital camera, giving a file size of 5.5Mb.

enhance

The brightness, contrast and colour of each image was adjusted to suit my own monitor before loading them into the web page.

share

There is a large number of programs specifically for designing and producing web pages, including Adobe PageMill, Dreamweaver, and Microsoft Front Page. For the beginner, it is probably best to choose a simple one to start with. Several imaging programs offer the option of converting a series of images into a pre-designed web template. I chose the web photo gallery option [file > automate > web photo gallery] in Adobe Photoshop. This automatically re-sizes the images according to a set of preferences [1]. Different layouts are possible, as shown on the screen. Simply select the source folder containing the images (ensure that they are all in the right orientation first) and click OK. The utility places the images into a web page, which can be opened in web browser software such as Netscape or Internet Explorer. Clicking on the small thumbnails produces a larger version in the centre. It is a very useful and quick way of producing a simple web folio [2].
↓

! For complex websites it is probably worth doing a sketch on paper first. Note the pages, their contents and how they link together. Websites can become very complex, and good planning is essential!

3/ Image size box, showing the image at 6in high, at a resolution of 72 ppi.

4/ The JPEG dialog box, showing amount of compression, image size and download time with a specific speed of modem.

3 image size

Pixel Dimensions: 371K (was 9.4M)

Width: 293 pixels

Height: 432 pixels

Document Size:

Width: 4.072 inches

Height: 6 inches

Resolution: 72 pixels/inch

☑ Constrain Proportions
☑ Resample Image: Bicubic

OK
Cancel
Auto...

4 jpeg dialog box

Matte: None

Image Options

Quality: 5 Medium

small file — large file

Format Options
◉ Baseline ("Standard")
○ Baseline Optimized
○ Progressive

Scans: 3

Size

~420.74K / 74.33s @ 56.6Kbps

OK
Cancel
☑ Preview

For more complex sites, you will need to prepare the images yourself. The first job is to produce two versions of the images, one for the small thumbnail used in the contact sheet and the other for the larger higher resolution version. As the resolution of computer monitors is only 72 dpi, this is the size the images are reduced to. Using a program like Photoshop, or Paint Shop Pro, I re-size the images to either 6in high, or 6in wide if horizontal in format [3]. The thumbnails are produced to a size of 2in at 72 dpi.

After re-sizing the images I sharpen them using the unsharp mask filter. As discussed earlier, you will need to experiment to find the right settings for your images, but here I used settings of strength 150, radius 1, threshold 1.

I save the images as JPEG files, which allows you to select a compression ratio, and see a preview of the effect on screen [4]. The key is to make the images small enough for fast download times, whilst retaining good quality. Approximate download times can be seen for various speeds of computer modem. You can also select how the file is downloaded: standard or progressive. In standard mode,

the image is revealed one line at a time, whilst in progressive mode the image is revealed with increasing resolution overall.

The final stage was to upload the finished pages to my Internet Service Provider (ISP) using the instructions provided by the company. You may eventually want to have a website with your name in the title e.g. yourname.com, and several companies offer the service of finding and registering the name for you. You will need to pay an annual fee for this.

8

5/ A <u>search facility</u> within the page allows you to type in or select specific subjects, in this case 'Big Cats'.

6/ The search links to a gallery of 'Big Cat' images, which can be <u>viewed</u> or <u>ordered</u>.

7/ A gallery page from Steve Bloom's site where images can be downloaded.

8/ A digitally enhanced image of a chimpanzee from a gallery page.

This example is from the website of Steve Bloom, a wildlife photographer who has a large, complex site for displaying and marketing his work. It contains a search facility, as well as the capability of ordering fine art prints on-line.

5 **search facility**

home | licensing | gallery | login | contact | steve**bloom**

Search for images by keyword(s) or image number.

Keyword: []

[search]

All Words (and) ● Any Words (or) ○

or

This Theme only: [Big Cats ▼] [go]

or

This Subject only: [▼] [go]

6 **search links**

new search

7 **gallery page**

home | gallery | the prints | prices | shopping cart | steve**bloom**

Back to Prints page

Aerial elephants running Antarctica 2 Baby Orangutan No.1

Chameleon in the Rain Charging Rhino no. 2 Charging Rhino no. 3

emailing images

Email is now a popular method of communication, for both business and home use. Not only can you send text messages, but you can also send digital file attachments with an email. These can be pictures, sound or even video clips. Much of the material for this book was sent to the people working on it as email attachments.

Most users of email use modems to access the internet and email. A modem converts a digital signal into an analogue one to send it. Another modem, on the receiving computer, then converts it back to a digital signal so that the message can be displayed on the computer. Modems are relatively slow in their operation and are dependent on the speed of the telephone line.

So, it is important that any attachment to an email is kept as small as possible. The same principles apply as for images in web pages, where the resolution of the image matches the resolution of the computer monitor – usually 72 ppi.

shoot

If you are scanning prints or negatives specifically for email, then <u>scan the pictures at a resolution of 72 ppi,</u> and at a linear size appropriate to the intended use, perhaps 6in high or wide. This will yield a file size of approximately 25Kb.

If you have digital files already, from a scanner or camera, they will probably need <u>re-sizing for email transmission.</u> In the <u>image size dialog box</u> in your imaging software, set 72 ppi as the resolution, and a height or width of 6in. This will give a file size of 376Kb. <u>Save</u> this on one of the <u>medium settings</u> in the <u>JPEG dialog box</u> and this will result in a <u>file for transmission of around 30Kb</u> which will take <u>six seconds</u> to transmit using a <u>56,600Kbps modem</u> [1].

enhance

Before sending images I <u>adjust brightness, contrast and colour,</u> and apply an <u>unsharp mask</u> filter so that the images look good on the screen. Bear in mind here that the person receiving the images may not have their screen adjusted like yours, so the images may well appear differently on their screen.

share

There are several ways of sending emails, including dedicated programs such as Microsoft Outlook and Eudora. Beware that <u>some free services,</u> such as Microsoft's Hotmail has a <u>limit on the size of email attachments</u> that can be sent. In this example I was <u>sent</u> some images by a picture researcher for possible use in this book, which I <u>viewed</u> in the Hotmail software. This <u>displays</u> not only the <u>names of the files,</u> but also the <u>images as well.</u> In this case only one is shown due to space, but the others can be accessed by <u>scrolling</u> down the page. The sender of the email typed in the <u>brief message</u> in Outlook, then clicked on <u>insert</u> and was prompted to <u>select the location of the files to attach</u> to the document [3].

Depending on the software used to open the email, the images may appear as images, or need to be opened by double clicking on the icon [4].

1 jpeg dialog box

Matte: None

OK

Cancel

Image Options
Quality: 5 Medium

☑ Preview

small file ——— large file

Format Options
○ Baseline ("Standard")
● Baseline Optimized
○ Progressive
Scans: 3

Size
~33.95K / 5.99s @ 56.6Kbps

! **Contact sheets** – I am often sending articles to magazines with images. It is useful to make up a **contact sheet** of all the images to send as one file. Several programs can do this automatically – I used **Photoshop's contact sheet facility** [file > automate > contact sheet] [5] to generate this. The size of this contact sheet will be around **1Mb**, which compresses down to around **35Kb** when saved as a **JPEG** file [6]. The images will still be good enough for an editor to see them on their monitor.

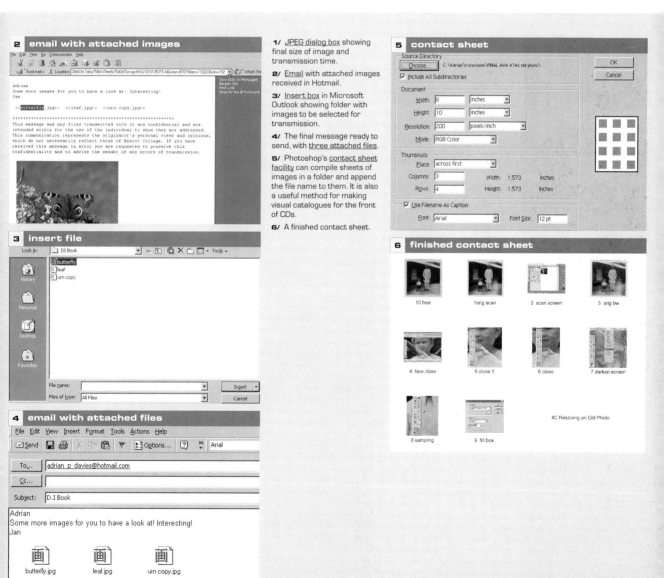

2 email with attached images

3 insert file

4 email with attached files

1/ JPEG dialog box showing final size of image and transmission time.

2/ Email with attached images received in Hotmail.

3/ Insert box in Microsoft Outlook showing folder with images to be selected for transmission.

4/ The final message ready to send, with three attached files.

5/ Photoshop's contact sheet facility can compile sheets of images in a folder and append the file name to them. It is also a useful method for making visual catalogues for the front of CDs.

6/ A finished contact sheet.

5 contact sheet

6 finished contact sheet

10 final 1orig scan 2 scan screen 3 orig bw

4 face close 5 clone 1 6 clone 7 darken screen

8 sampling 9 fill box 4C Restoring an Old Photo

appendix

1

file formats, compression, computers

tiff

jpeg

image compression

A file format is the way in which any computer data is stored. A word-processed document might be a text file, whilst many digital images are TIFF files. On PCs you will see a three-letter suffix after the file name, indicating the type of file format – .txt, or .tif for example.

There are a large number of file formats available for digital images, but you will probably only regularly use two or three, depending on your software package.

This is the commonest image file format, recognised by all major imaging programs as well as other computer software such as desktop publishing and presentation graphics programs such as PowerPoint. Images can be compressed, using LZW or other routines, without loss in quality. You will usually achieve between 30–50% saving in file size depending on the content of the image. Beware though that compressed TIFF images may not be recognised by some software. Unless you will always be using a Macintosh computer, choose the PC format [2].

This is a lossy compression format, which reduces the size of the stored file by throwing away some data during the saving process. The smaller the file size the lower the quality. The main question here is can you see the loss in quality?

JPEG is an excellent format for reducing file sizes to include small images in web pages, or for sending images as email attachments. As a rule, try to make images no larger than 20–25Kb for web pages [3].

Because digital images tend to be quite large (often several megabytes) they are often compressed when stored to save disc space. There are basically two types of compression – lossy and lossless. An example of lossy is the JPEG format, which throws away data during the process. Very high compression ratios can be achieved, enabling a 4Mb file to be stored in as small a space as 100Kb or less. Never compress an already JPEG-compressed file, as the effect is cumulative and quality will suffer.

Lossless compression such as TIFF LZW retains all data and therefore quality, but can only achieve around 50% compression.

2 tiff dialog box

Byte Order
- ● IBM PC
- ○ Macintosh

OK
Cancel

☑ LZW Compression

3 jpeg dialog box

Matte: None

Image Options
Quality: 5 Medium
small file large file

Format Options
- ○ Baseline ("Standard")
- ● Baseline Optimized
- ○ Progressive
- Scans: 3

Size
~24.68K / 4.36s 56.6Kbps

OK
Cancel
☑ Preview

1/ Original scanned image – 200Kb.

2/ TIFF dialog box in Adobe Photoshop – note options for PC or Mac, and the facility for lossless LZW compression.

3/ JPEG dialog box showing slider for quality versus image size. Note the size of the final stored file (24Kb) at the bottom and approximate transmission time (4.3 seconds) using a 56.6Kbps modem.

4/ JPEG compressed version – note the 'blocky' appearance of the image (the effect has been exaggerated for the purposes of this book).

! **Pixels per inch versus dots per inch** – Images from digital cameras and scanners contain pixels, so their resolution is quoted in pixels per inch, or ppi. Most printers lay down a series of dots, which combine to form the pixels of the image, so they are quoted in dots per inch, or dpi.

Two plant images by Adrian Davies, shot on a 3 million pixel SLR type digital camera, with a short telephoto lens.

storage

Your PC will probably have a large hard disc, nowadays several gigabytes in size. But it is essential to have a copy, or back-up, of your data, in case the hard disc fails or becomes corrupted. Various devices are available for storing digital images, but probably the commonest is the CD writer. CDs can hold up to 650Mb of data, and are now very cheap to buy. The data on a standard recordable CD is permanent and cannot be altered, but a re-recordable type is available, called CD RW. Beware though as these are not compatible with all CD players.

Other options include removable hard discs; such as the 100 and 250Mb Zip and 1Gb Jaz drives. These use magnetic discs, so are vulnerable to magnetic fields and the like.

resolution

The resolution of an image is the amount of detail that it can contain. The number of pixels that it contains governs this mainly, but not exclusively. An image from a 3 megapixel camera can be enlarged more than the image from a 2 megapixel camera before the pixels become apparent. Similarly, a negative that has been scanned at 600 ppi can be enlarged more than a negative scanned at 300 ppi.

But it is ultimately the resolution of the printer that will govern the quality of the final print. Nowadays, ink jet printers with resolutions of 720, 1440 and even 2880 dpi are common.

Ink jet printers work by spraying a pattern of minute dots of ink on to the paper. Most ink jet printers use four colours – cyan, magenta, yellow and black – to reproduce images, but many photo quality models also use two extra colours, light cyan and light magenta.

How the printer reproduces the colour and tone of each pixel is a highly complex process, but simply, in order for the printer to reproduce any pixel within the image, four (or six) dots of colour are needed, with many printers varying the size of dot. A good rule of thumb to find the actual resolution of a 720 dpi printer is to divide 720 by 4, giving 180 pixels per inch. The actual resolution will depend on many other factors, such as paper quality, and the way in which the

pattern of dots is arranged. It is worth testing your own printer, but a 720 dpi printer will probably have an optimum resolution of around 200–220 ppi.

The quality of the paper is extremely important, and specially coated ink jet paper is essential for the best quality, though other papers can be used for artistic effects.

Another useful rule of thumb for sizing digital images is to divide the number of pixels in the image by 300. The resulting figure, in inches, is the size of the print that can be produced.

For example, an image with a resolution of 1200 x 1000 pixels will print to a size of 4 x 3in. This is a conservative estimate and larger sizes can usually be obtained with little or no loss in quality.

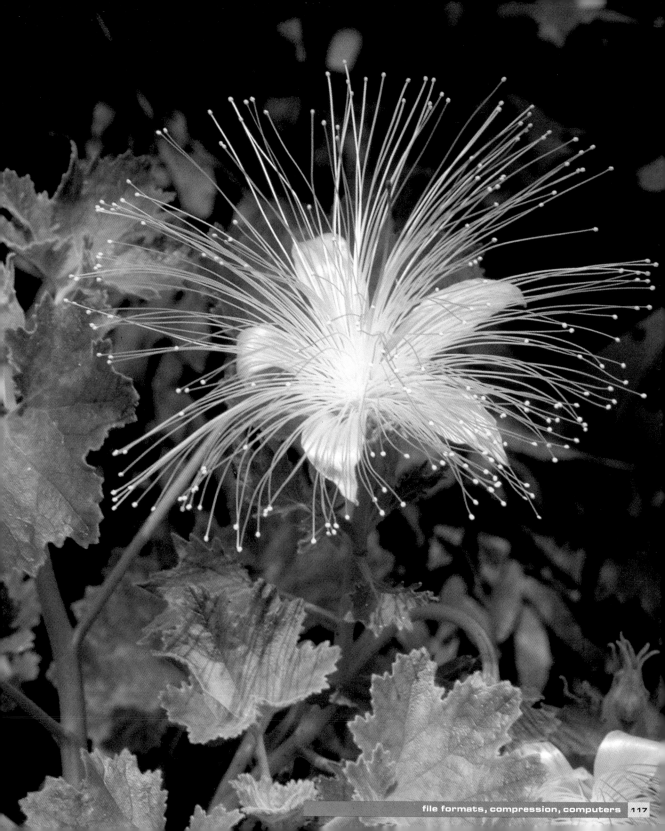

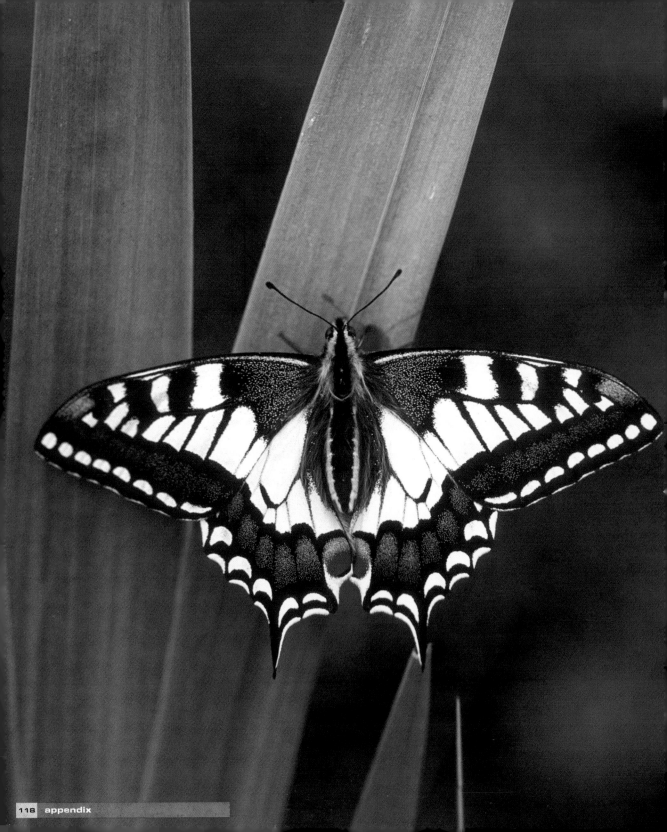

A butterfly caught on camera
by Adrian Davies.

computers

There are basically two main types of computer for digital imaging, the IBM compatible (the PC) and the Apple Macintosh. These use different operating systems, and software may only be available for one type or the other. Which you use will be dependent on personal preference, and whether you have any other uses for the machine (children's homework for example!).

The main requirements of a computer for digital imaging are:

- **Memory** – A large amount of memory (RAM) – an absolute minimum of 64Mb is recommended, though 128Mb or more is preferable

- **Monitor** – A good high quality monitor, that is, above all, sharp

Other add-ons:
- **CD Writer**

- **Graphics Tablet** (a device that replaces the mouse with a stylus or pen which many users find easier to use than a mouse)

software

Several software programs are available for beginners to digital imaging, including:

- **Adobe Photoshop** (expensive, but the industry standard)

- **MGI PhotoSuite**

- **Adobe Elements** (a much cheaper cut down version of Photoshop)

- **Paint Shop Pro**

Some of these, such as PhotoSuite, have two modes, either guided activities, where you are given a series of prompts explaining how to perform certain operations, or an advanced mode. The guides can be useful for the beginner.

good practice

Never work on your original images.

Make a copy of your image before you start work.

Keep your original camera file or scan as an archive copy. You may need to go back to the original one day to re-do the work!

Use adjustment layers to make changes to things like brightness and contrast so that they can be re-edited at a later date.

You will probably end up with several versions of an image:

- the archive version
- an enhanced image
- the image sized for printing
- a version sized for a web page or email attachment

A simple flower image by Sonya Cullimore is brought to life using digital techniques.

glossary

This simple glossary should help you navigate your way through the jargon and technical terms used in digital photography.

Aliasing
Where curved or diagonal lines appear jagged due to the way they are displayed on the bitmap pattern of image processing programs.

Analogue
A continuously variable signal. Photography with film is an analogue process.

Bit depth
The number of colours or grey tones used to represent a digital image on the monitor, e.g.

8 bit = 256 colours/tones
24 bit = 16.7 million colours/tones

Bitmap
An image formed by a square or rectangular grid of square pixels, where each pixel has an address and tone, or colour value.

Byte
The standard unit of computer storage. One byte is composed of 8 bits.

1 Kilobyte (Kb) = 1024 bytes
1 Megabyte (Mb) = 1024Kb
1 Gigabyte (Gb) = 1024Mb

CD ROM
Compact Disc, Read Only Memory – a compact disc that can only be read.

CD R
Compact Disc Recordable – a user recordable disc able to store around 650Mb of data. They are used extensively for archiving and storing images.

CD RW
Compact Disc Re-Writable – a recordable CD that can be erased and have new data recorded on to it.

CCD
Charge Coupled Device – the basic imaging sensor containing pixels used in scanners and most digital cameras. There are two basic types: rectangular area array types, used in most digital cameras, and linear array, used in scanners.

CMOS
An alternative imaging sensor used in a few digital cameras.

CMYK
Cyan, magenta, yellow, black – the four colours used in the four colour printing litho process for books and magazines, and by ink jet printers.

CompactFlash
A type of card storage system used in digital cameras.

Compression
Reducing the size of the stored digital file by reducing the amount of information required to store it. There are two types; lossy, such as JPEG, and lossless, such as the LZW option of the TIFF format.

Digital
Sampling an analogue signal so that it is converted into a series of discreet values that can be recognised by a computer. A scanner converts analogue images into digital information.

Dots per inch (dpi)
This is the basic unit of resolution of a printing device.

Feathering
Softening the edge of a selection within an image-processing program.

File format
This is the way in which a computer file is stored. Examples are TIFF, JPEG and BMP.

Filter
1. A glass or plastic attachment for the front of a camera lens to modify the light passing through it. Examples are polarising and skylight.

2. A feature of image-processing programs for enhancing or modifying digital images. Examples are sharpening, and 'lens flare'.

Focal length
An indication of the angle of view of a lens. The shorter the focal length, the wider the angle, and vice versa.

Flash memory
A type of computer memory that 'remembers' the data even when power to it is switched off.

GIF
A file format used for 8 bit (256 colour) images in websites.

Greyscale
An image (usually 8 bits per pixel), containing a range of grey tones from black to white.

Hue
The name of a colour, e.g. red, magenta.

Ink jet
A type of computer printer capable of photographic quality output.

Interpolation
The ability of computer software to invent new pixels to increase the effective resolution of a digital image.

JPEG
A file compression standard capable of reducing the size of stored files by discarding 'redundant' data. Using it may affect image quality.

Levels
A control found in programs such as Adobe Elements, Photoshop or Paint Shop Pro, for adjusting the density of images.

Macro
The ability of a lens to focus close to a small subject.

Megapixel
One million pixels – the resolution of most digital cameras is now rated in megapixels; common examples are 2, 3, 4 megapixel.

Memory stick
A type of storage card used in Sony digital cameras.

MicroDrive
A miniature disc drive, developed by IBM, used in upper end digital cameras. They can currently store up to 1Gb.

Pixel
Short for 'Picture Element' – the smallest element of a digital image. CCDs are composed of many thousands or millions of pixels, each of which is sensitive to light. A voltage is generated in proportion to the amount of light, rather like a light meter.

Pixels per inch (ppi)
The basic unit of resolution of a scanner.

RAM
Random Access Memory –
temporary memory used by the
computer when it is switched on.
Any data in memory is lost when
the computer is switched off.

Resolution
The quality of an image,
dependent primarily, but not
exclusively, on the number of
pixels it contains.

RGB
Red, green, blue – the three
primary colours of light.

Saturation
The strength or purity of a colour.

SmartMedia
A type of storage card used in
digital cameras.

Thumbnail
A small, low-resolution version of
an image used to make contact
sheets, or previews in websites.

TWAIN
Technology Without an
Interesting Name (!) – the
interface used by many scanners
and digital cameras.

Unsharp mask (USM)
The best type of sharpening
filter, because it can be
adjusted to suit the particular
image requirements.

USB
Universal Serial Bus – a type of
connector used on computers for
connecting peripheral devices
such as scanners and printers.

Zip disc
A type of removable hard disc.
There are currently two types,
capable of holding either 100
or 250Mb.

contacts

Barry Beckham

Barry Beckham lives in Hornchurch in east London. Having been interested in photography for many years, he started off joining a local camera club, then quickly moved on to developing and printing his own images. As a result he became heavily involved with club competitions and exhibitions both in black and white and colour.

Some years ago a friend introduced him to Adobe Photoshop 2.5 and this is when digital imaging took off for him.

Barry now works 100% digitally and also writes regularly for Digital PhotoFX (Now Digital Photo), Digital Photography, Digital Photographer and Digital Photo User.

His website contains several Photoshop tutorials, all of which have been featured in UK magazines over the past few years. Alternatively for a modest fee you can purchase this entire website on CD so you can browse all the tutorials without being connected to the internet.

www.bbdigital.co.uk

pages: 53, 66–67,112–113

Steve Bloom

Steve Bloom is a photographic artist who produces evocative images of the natural world with his creative approach to photography. Professional Photographer magazine describes him as a 'photographer at the leading edge who sets the agenda for the future'. Born in South Africa, Steve moved to London during the late seventies where he founded a photographic stills special-effects company.

In 1993 he began taking photographs of wild animals and soon embarked on a new career as a wildlife photographer. He has won a number of awards and his highly popular images are published worldwide. He is the author and photographer of the book, 'In Praise of Primates', which has been published in ten languages and features two years' work during which he photographed monkeys and apes around the world.

www.stevebloom.com

pages: 72–73, 98–99, 109

Jon Bower

Jon Bower is an environmental scientist. His work frequently takes him all over the world, allowing him to indulge in a belated second career as a professional photographer. Jon has lived and worked for many years in Asia, and has been photographing weird, wonderful and downright nasty places worldwide for over 20 years. Jon's other interests include keeping his wife happy, high-end audio, classical music, science fiction and dark, dark chocolate. Jon's image website is at www.apexphotos.com and many of his global environmental and travel photographs may be purchased from www.alamy.com.

www.apexphotos.com
jon.bower@virgin.net

pages: 22–23, 24, 93

Sonya Cullimore

A self-taught photographer residing in her birthplace of Timaru, New Zealand, Sonya took up photography at the age of 27 and what started out as a hobby has fast become a passion.

For Sonya photography is about seeing and perceiving images through the mind's eye and portraying them in a way that challenges reality. She is inspired by colour, whether it be bright and contrasting or harmonious and subtle.

Two years after picking up her first camera, Sonya has received over 25 worldwide photographic awards, providing her with the encouragement to go on to exhibit her work.

http://go.to/digitalvisions
omzig@es.co.nz

pages: 61, 62, 120–121

Adrian Davies

The author, Adrian Davies, has written several books and over 100 articles on various aspects of digital photography. He is lecturer in photography and digital imaging at NESCOT, a college in Surrey, where he has developed various courses in digital photography, as well as acting as consultant to various companies and institutions.

His main areas of interest in imaging are wildlife and natural history subjects, which he has started to capture with digital cameras. His work is represented by several image agencies, including the BBC Natural History Unit in England, and Bruce Coleman Inc in the USA.

adrian_p_davies@hotmail.com

pages: 19, 28, 37, 38, 41, 47, 48, 96–97, 100–101, 106, 107, 110, 116, 117, 118

Luzette Donohue

After working as a professional photographer for eight years, Luzette embraced the world of digital imaging and now works as a freelance illustrator combining traditional and electronic media. Her illustrations have appeared in books and magazines as examples of the creative potential of Adobe Photoshop. She teaches digital imaging and photography, and regularly presents practical workshops on these topics for groups such as the Royal Photographic Society.

www.luzette.com
illustration@luzette.com

pages: 55, 68, 69, 71

Rod Edwards

Rod Edwards is an acclaimed professional photographer who works in the publishing, advertising, design and corporate areas of the photographic industry and has worked for many major blue chip clients.

Whilst he is proficient in all formats of the traditional colour and black-and-white photographic medium, he is becoming increasingly involved with digital media and digital image manipulation.

He markets his images from both his base in East Anglia, UK and also through international photographic agencies including Getty Images, The Telegraph Colour Library, Photonica and The National Trust Photographic Library. He is also a member of the Association Of Photographers in London.

www.rodedwards.co.uk
rje@rodedwards.co.uk

pages: 26–27, 44–45, 64–65, 76–77, 81

Ray Grover

Ray is a manager of R&D activities in the electronics industry. He has been a keen amateur photographer since 1995. He is a member of the South Manchester Camera Club and has wide photographic interests. His first love is the landscape, but an interest in still life and creative work blossomed in cold dark evenings when outside activities were impossible. In 1998 he gained the Licentiate and then Associateship levels of distinction of the Royal Photographic Society with creative flower pictures. He has won many prizes, the best being the Amateur Photographer of the Year 2000. In that year he started to use digital techniques as a way to extend image possibilities, and more recently his interest in natural history has grown.

rgrover@mighty-micro.co.uk

page: 89

Daniel Lai

Daniel Lai was born in Kuala Lumpur, Malaysia, in 1971. He currently lives in New Jersey, USA and has been there since 1999.

In addition to pursuing his career as a fine art photographer, he is also currently a photography student at Montclair State University, NJ. He started his fine art career as a self-taught photographer three years ago. His images have been published on his website, some photography magazines, online photography workshops and showcases. They are also included for private and non-profit exhibitions in local townships, and private collections.

www.danielart.com
danielart@danielart.com

pages: 91, 95

George Mallis

George Mallis, inspired by the coastal and landscape beauty of Long Island, New York, USA and the grandeur of creation, portrays ordinary locales through his images with unusual perspective to nurture a spirit of harmony and love in a world full of joy and mysterious hardship. A graduate of New York University and Hofstra University with a Master of Science in Secondary Education, George is the official photographer of the Walt Whitman Birthplace. His images grace the private collections of former President Gerald R. Ford and New York State Parks Commissioner Bernadette Castro.

www.georgemallis.com
gmallis@optonline.net

pages: 4–5, 75

Bryan Powell

A very keen amateur photographer from his early 30s – Bryan became a professional in 1985 when he started his own photographic studio after retiring from the London Fire Brigade.

In 1992 he began his conversion from film to digital when he undertook a two year full-time digital course at Nescot College in Epsom in Surrey, UK.

His studio now specialises in digital work for clients although he admits to still shooting his favourite animal and flower pictures on transparency film.

He is a well-known judge and lecturer in digital techniques around the photographic clubs and societies of the British Isles.

b.powell@netmatters.co.uk

pages: 6–7

Phil Preston

Phil Preston lives in Buckinghamshire, UK, and has been interested in photography for about 30 years. Largely self-taught, his main areas of interest are landscape, nature, architectural and abstract photography.

Most of Phil's photographs are currently produced using film cameras, but digital imaging has become an important part of his photography, and ultimately, he expects his photography to be 100% digital. He has had a number of images printed in UK photographic magazines, including Digital Photo User, What Digital Camera and Digital Photo. His personal website has also been given a number of awards by photographic organisations including Professional Photography.com and Profotos.com. Phil is currently developing a number of tutorials for PhotoImpact on his website.

www.digital-fotofusion.co.uk
phil.preston@digital-fotofusion.co.uk

pages: cover, 15, 25, 78

Walter Spaeth

At the age of 20 in 1972, Walter Spaeth discovered the creative and technical possibilities of photography in the black-and-white darkroom of a friend. Photography was far less sophisticated then than it is today and this proved to be an advantage, as Walter spent his first years concentrating on learning the basic techniques and principles of composition.

In the mid-90s computers made their appearance in the photo scene and allowed the editing of pictures, something which Walter started doing with great fascination and success. Between 1990 and 2000 Walter won more than 30 awards, including Deja-GmbH's 10 000 Mark 'Take care' award, which he received in a festive ceremony at the Photokina 2000 in Cologne for his excellent work 'World Protect I'. In his work Walter Spaeth creates whole visual worlds, which combine light, colour, and forms into ever new compositions that captivate the viewer's eye.

www.artside.de
mailto@artside.de

pages: 10–11, 57, 83, 85

John Wigley

Photography has always been John Wigley's main interest, from the day he bought his first 'real' camera, an Agfa Isolette 2-square bellows camera. It was not until 1982 that he took a serious interest in photography, building his first darkroom and launching into black and white, Cibachrome and colour print production. John's interest in digital imagery started in 1992 when the firm he worked for changed to I.T. and the darkroom was dismantled and a computer studio installed instead. In 1999, along with 16 other enthusiasts, he became founder chairman of The Southern Digital Imaging Group in southern England. John leans towards the artistic use of digital imaging and likes close-up, landscape and 'creative' photography.

john.wigley@ntlworld.com

pages: 42, 49, 58

acknowledgements

A special thanks to Adobe UK Ltd.,
JASC Software, and MGI Software
Corp for providing the programs
used throughout this book.
Also, to all those photographers
who submitted images for this
project. It is a great pity we did not
have the space to feature them all!
Finally, to Kate Stephens and her
team, in particular the editor,
Natalia Price-Cabrera and picture
researchers Sarah Hope and Sarah
Jameson, for help with the
production of this book.